ADAMS
CENTRAL
H.S. ART DEPT.

WATERCOLOR PAPER HANDBOOK

WATERCOLOR PAPER HANDBOOK

WERNER MERTZ

WATSON-GUPTILL PUBLICATIONS/NEW YORK

Senior Editor: Candace Raney
Associate Editor: Carl Rosen
Designer: Howard P. Johnson
Production Manager: Ellen Greene
Typographer: Trufont Typographers, Inc.
Set in Palatino

First published in 1991 in New York by Watson-
Guptill Publications, a division of BPI
Communications, Inc., 1515 Broadway, New
York, N.Y. 10036

Library of Congress Cataloging-in-Publication
Data
Mertz, Werner.
 Watercolor paper handbook / Werner Mertz.
 p. cm.
 Includes Index.
 ISBN 0–8230–5678–3
 1. Watercolor painting. 2. Artists'
materials. 3. Paper products. I. Title.
ND2422.M47 1991
751.42′2—dc20 90–29180
 CIP

Distributed in the United Kingdom by Phaidon
Press Ltd.

Manufactured in Singapore

First printing, 1991

1 2 3 4 5 6 7 8 9 10 / 95 94 93 92 91

For Mary Angela

CONTENTS

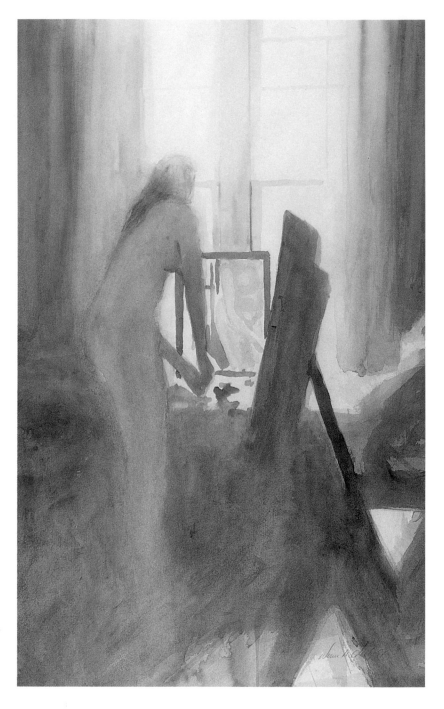

Summer Studio
26″ × 16″ (66 × 41 cm)
Fabriano Artistico
140 lb. Cold Pressed

*On the first try the head on this figure was positioned at a wrong angle.
By scrubbing the area with clear water and a bristle brush, the surface of
the paper was removed. Once dry, the head was painted in the present
position without any noticeable effect.*

INTRODUCTION

Paper, paint, and brushes are the three primary tools used in watercolor painting. The paper support is the most important element of the three. Once a painting is started on a particular paper, the paper cannot be changed. Moreover, the paper dictates the extent to which the technique chosen by the artist can be carried out successfully.

Even when the artist has decided on the subject of a painting and the techniques to be used, it is not a simple matter to choose a compatible watercolor paper. Two different paper manufacturers may describe their products identically when in fact the papers have different physical compositions or chemical compositions or both. The difficulty in choosing correctly is further compounded because manufacturers supply little or no information about the performance characteristics of the watercolor supports they sell. Consequently, the artist is forced to select paper on a trial-and-error basis, without any indication of suitability for particular applications.

A number of factors influence the artist's choice of paper. The physical properties of paper are important considerations. These properties include composition, manufacturing processes, sizing, and texture. Environmental conditions are also significant factors, humidity being the most critical. And the artist must consider the nature of the water-based medium, be it watercolor paints, ink, dye, or gouache.

As a child I enjoyed drawing, but because of the German occupation of Denmark, my native country, during World War II, there was a shortage of just about everything. Drawing paper, coloring books, and art supplies in general were nonexistent. My drawings were limited to small pieces of scrap paper. From these small scraps I realized that the quality of paper varied a great deal, and at a very early age I began to feel the surface of paper to determine its quality.

In the fourth grade I saw my first large white sheet of watercolor paper. It was about 16″ × 20″ (41 × 51 cm) and in the form of a watercolor block, glued on four sides. My art teacher, who also taught physics and geometry, was an excellent watercolor painter himself, but he taught watercolor the same way he taught physics, step-by-step without any tolerance for creativity. Our first lesson, one I've never forgotten, was to paint an even, controlled wash in the form of a circle. My teacher placed one of the watercolor blocks on a forty-five degree angle, then, loading his brush with watercolor paint, he applied the paints in such a manner that there would be enough water on the paper to form a line of water across the surface, but not so much that it would run. By keeping the paper wet in this manner he would achieve an even wash as he continued painting downward on the paper.

I still use this particular technique, but only on a hard-sized paper with little absorbency, as an absorbent surface will not hold the watercolors long enough to allow an even flow of colors.

When I moved to the United States in 1954, I tried oil painting, but that was a futile effort as I never lived in one place long enough for the oil paints to dry. I turned to watercolor and searched in vain for a paper resembling the paper I had used in school. Not being able to find a suitable paper for watercolor painting, I turned to drawing. After much research, I found suitable watercolor paper, and I hope that my efforts will help others find the watercolor support that best suits them.

It is my intent to provide a guide for selecting among the more common papers used in traditional Western watercolor painting. This guide is in the form of a catalog of the watercolor papers. The major characteristics of each paper are described, and examples of the results are included. The catalog is based on my research and experience as a professional painter and teacher in the watercolor medium.

9

FACTORS INFLUENCING PAPER CHOICE

The watercolor artist has a tendency to get "stuck" on one type of watercolor paper. This is usually the result of trying only a few different papers. Unless an artist is lucky in selecting a paper that just happens to suit his or her taste, the subject to be painted, and the techniques to be used, the results can be frustration and failure. Consequently, the artist will return to the "comfortable" paper.

There are too many factors influencing the artist's choice of paper for the artist to simply select a surface at random. How abusive is the painter to the paper? Are delicate lines or smooth transitions desired? Are glazing techniques part of the painting? These are but a few of the important questions an artist should consider before selecting a watercolor support.

Knowing what a paper will or will not do for the individual painter can eliminate most problems and at the same time can enhance the techniques used for a particular painting. It is my hope that this modest work will help the watercolor painter to select papers suitable to his or her taste, as well as to simplify the selection.

Fiber Content

Paper is a sheet of material made from bonding a fibrous substance. This substance can be animal, vegetable, mineral, or synthetic. The most common fibrous material for papermaking is vegetable. Wood and cotton fibers are the ones used by the paper industry.

A fiber called bast, a derivative of the flax plant, was the first fiber used in Western papermaking. The bast fiber was used predominantly for making linen. It was discovered that rags from linen were particularly well suited for papermaking, and for some time paper made from linen rags comprised the majority of paper on the European market. With the introduction of other materials for paper production (wood in particular) the quality of paper was measured by its rag content, a reference to the amount of linen it contained. Although cotton fibers have replaced linen rags in almost all high-quality papers, the term *rag content* is still used on the current market. The term is a misnomer because modern papers may still be referred to as 100 percent rag even though they may contain only a small portion of actual linen rags.

High-quality paper consists mainly of fibers made of cellulose. Cellulose is strong, flexible, and hydrophilic (it loves water), and these are the qualities papermakers are after when selecting materials for their products.

All plants contain cellulose, but they also contain other chemicals not desired in the production of high-quality paper. The plant containing the least amount of impurities and containing long fibers suitable for both textiles and paper is the cotton plant. Although wood is abundant and is used to manufacture the majority of consumer paper products, wood contains large amounts of impurities considered unsuitable for high-quality papers. Papers made from wood are sometimes referred to as sulfite papers. This term is derived from the pulp-producing process that treats the wood chips with sulfur derivatives. These papers tend to deteriorate rapidly because of these undesirable chemicals. Cotton fiber is the best choice for producing high-quality paper.

It is not uncommon for a manufacturer to add various chemicals to the paper pulp, to the sizing, or both. These chemicals often change the pH of the paper. The pH is the measurement of acidity or alkalinity of a solution. Papers made from sulfite, linen, or cotton should have a neutral pH if they are to have archival qualities. If the pH changes during paper production and the paper manufacturer wishes to extend the archival qualities of the paper, other chemicals must be added to achieve a neutral pH.

Surface Texture

Papers can be classified as either laid or wove. This classification is based on the paper formation process.

The laid surface shows distinct impression lines in the form of a grid pattern left by the screen in the paper mold. The surface of the wove paper is formed on a much finer screen and leaves the paper surface without a distinct pattern. Wove paper is the choice of most watercolorists.

Wove papers can be classified further by surface texture. The three types of texture in this classification system are cold pressed, hot pressed, and rough. This classification is provided by the manufacturer and is specific only to each respective line of paper. There is no standard in the industry as yet.

The hot-pressed surface is the smoothest of the three. This is due to the production process by which the paper is pressed between two hot rollers. Cold-pressed paper is subjected to less pressure as the rollers are not heated. This results in more surface texture. The rough surface is subjected to the least amount of pressure and again the rollers are not heated. Since the paper fibers are not as compressed, the resulting surface texture is rough.

The surface texture of watercolor paper plays a significant role in the painting process. This is because Western watercolor painting is dependent on a physical phenomenon known as colloidal suspension, which consists of minute particles suspended in a solution. For our purposes, the particles are the watercolor pigments. It is this suspension and its subsequent interaction with the surface texture that makes the painting process controllable.

The pockets on the surface of a textured sheet of watercolor paper can hold the paints in a colloid state long enough to allow an even flow of paint or, if desired, time to manipulate the paint to vary the density of pigments without interruptions in the paint value. The combination of sizing and surface texture are the variants in the physical composition of the paper that the watercolor painter has to consider before starting a painting.

Weight

I have chosen to discuss the most popular weight of watercolor paper—the 140 lb. The 90 lb. papers are prone to buckling, and unless stretched the buckling seems to interfere with painting. The 300 lb. weight papers are generally excellent supports for watercolors as they buckle less than the lighter papers. They, however, are too expensive for most watercolor artists. Most watercolor artists lean toward the 140 lb. weight, as it provides stability and keeps costs down.

Color

As traditional watercolor painting is painted with transparent paints, the white color is supplied by the paper. Consequently, watercolor papers are white. The white color, however, will vary; the variations may be difficult to notice unless a comparison is made with other papers.

Size

Individual sheets of watercolor paper are usually 22″ × 30″ (56 × 76 cm). This size originated in England and is referred to as an Imperial sheet. Some manufacturers do provide individual sheets both smaller and larger. Many handmade papers come in sizes smaller than 22″ × 30″ but rarely any larger. The largest individual sheet on the market is 40″ × 60″ (102 × 152 cm).

Price Range

The price range of watercolor paper varies greatly, but the price usually indicates the quality. Paper with a 100% rag composition is the paper of choice, and the price range for a single sheet of 140 lb. 22″ × 30″ is between $2.25 to $4.25. Handmade papers cost about three to four times more than machine-made papers. Always compare mail-order to art-store prices.

Absorbency

Atmospheric moisture is readily absorbed by paper, and the moisture content of the paper will affect the flow of solutions.

The physical phenomenon that draws moisture into the fibers is known as capillary action. This flow of solutions into the fibers is due to the surface tension of the paper and continues until saturation occurs. Absorption occurs along the grain of the paper. The term *grain* refers to the direction of the arrangement of fibers.

Controlling the flow of watercolor paint on paper can be difficult during periods of high humidity. The papers that are affected most by atmospheric moisture are soft and internally sized papers. As the moisture of a paper increases, watercolor paints, inks, and dyes begin to flow faster along the paper fibers. This can result in feathering or bleeding of the paints, because paints flow uncontrollably along the paper fibers (along the grain). Selection of a paper with hard, external sizing can compensate for periods of high humidity.

Reworkability

The ability to control watercolor paints on paper is what distinguishes Western watercolor paper from paper made for watercolor in Asia. Corrections are not possible on these fragile sheets of oriental paper. Western watercolor papers are not only much thicker, but generally they are sized, leaving watercolor paints on the surface long enough to be manipulated.

Some Western watercolor papers have little or no sizing, but the majority does (see *Sizing* below). In a paper not sized, excessive feathering can be a problem, as controlling the flow of paints may not be possible. Feathering, or bleeding, gives work a softer appearance on an unsized paper than on one that is sized. Feathering on a hard-sized paper often shows as fingerlike projections of paint, as the paint travels along the irregularities on the paper surface. This paint, when on the surface, can easily be manipulated, as long as it remains wet.

Corrections on a hard-sized surface, in the form of lifting paints, is often possible. The paints can be rewetted with clear water, then loosened by scrubbing with a bristle brush and lifted with a dry sponge or tissue. In addition, highlights can be created by scraping dry pigments off the surface. This technique is not recommended when painting on an absorbent surface. Unsized or soft-sized papers have the tendency to come apart in rather large chunks.

A hard-sized paper has the additional benefit of creating darker values of paint. Since paints sit on the surface, areas of darker value can be achieved by destroying the surface sizing. This can be done by scraping or sanding. Scraping an area while the paints are wet will allow the watercolors to enter the paper fibers, and the area scraped becomes darker. Lifting or otherwise correcting the paints in the area scraped, however, is not possible. If the area is sanded before paint is applied, the resulting surface changes the behavior of the paper. The paints are soaked into the paper fibers immediately on application and can't be changed.

*Surface detail of Fabriano Artistico
140 lb. Cold Pressed*

*Removal of surface of Fabriano Artistico
140 lb. Cold Pressed*

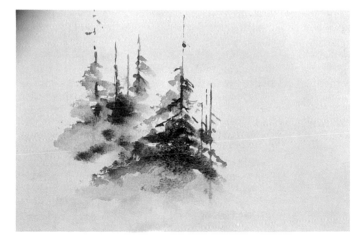

*Repainted surface of Fabriano Artistico
140 lb. Cold Pressed*

Sizing

A glue or gelatin sizing is included within the paper during the manufacturing process or applied externally to the sheet of paper after it has been made. The amount of sizing controls the absorbency of the paper and varies depending on the particular function of the paper.

Papers that have not been sized are called waterleaf and are very absorbent. An example of a waterleaf is a blotter. Unsized raw paper has few functions suitable for western artists or printers, and most papers are sized in some way.

Mass-produced papers are sized internally. The sizing is added to the paper pulp prior to the formation of the paper sheet, and the finished product does not receive any additional sizing. Watercolor papers, however, are sized after the sheet has been made. Handmade watercolor paper is sized sheet by sheet and air dried.

Watercolor papers vary considerably in the amount of sizing applied to their surfaces, and consequently papers vary in their rate of absorbency. The amount of sizing also influences the hardness of the paper. A heavily sized sheet is sometimes referred to as being hard-sized. Sheets with less sizing are called soft-sized.

A hard-sized paper is particularly well suited for controlling the flow of watercolors on a painting, as the pigments are kept from entering the paper fibers. This allows the painter enough time to manipulate the paints, either by adding or subtracting pigments, modeling, or a combination of the two. The major drawback of a hard-sized paper is its reluctance to accept large amounts of watercolor pigment. Some such papers have the tendency to allow pigments on a heavily saturated surface to precipitate out of suspension, leaving distinct pockets of pigments on the surface.

Papers with little or no sizing are eager to accept solutions. The less sizing contained in the paper, the more absorbent it becomes. This makes it difficult to control the blending of paints. The advantage of an absorbent surface lies in its ability to accept large amounts of pigments.

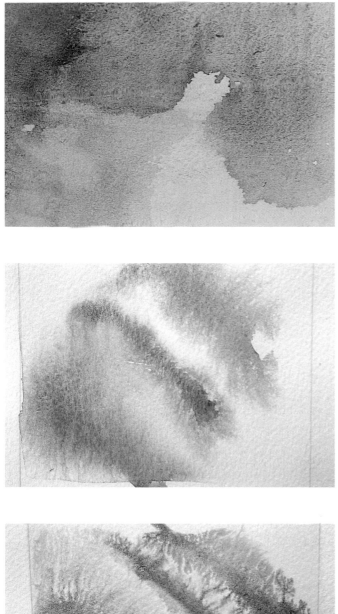

Precipitated watercolor pigments on a hard-sized paper.

Soft feathering of watercolor pigments on an unsized paper.

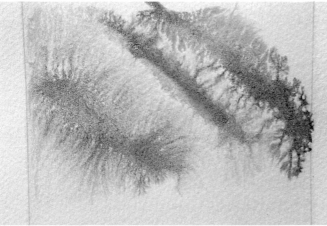

Distinct feathering of watercolor pigments on an externally sized paper.

COMPARING
THREE WATERCOLOR PAPERS

The three papers for this demonstration are Arches 140 lb. Cold Pressed, Fabriano Artistico 140 lb. Cold Pressed and Whatman 140 lb. Cold Pressed.

The only reliable information regarding classification of watercolor paper is the weight. Surface texture, in this case cold pressed, is a term used as a reference indicating a surface between hot pressed and rough.

I painted the three portraits in the same manner. The shadows were painted first with a fairly dry brush and, when dry, the rest of the painting was painted on top. Finally, highlights were brought out by scrubbing with a bristle brush, and the excess paint was removed with a dry tissue.

Arches paper was the easiest to control with this technique. The underpainting does not lift easily, and the colors are clear. Highlights are easy to achieve, as the surface can take an extraordinary amount of abuse even when wet.

Fabriano Artistico, with its smoother surface and greater absorbency, is harder to control. The underpainting has a tendency to lift a little when glazes are applied; this results in the painting losing some of its original character. Scrubbing

with a bristle brush to create highlights may frighten the novice painter because the paper fibers separate quickly, leaving small balls of paper on the surface. But once the paper is dry the paper balls can be removed.

Artistico is an excellent recipient of watercolor paints, and deep values are easier to obtain on this surface than on a hard surface like Arches.

The Whatman watercolor paper on today's market should not be confused with the Whatman paper made in the past. The only thing they have in common is the name. Today's Whatman paper has little or no sizing and is quite absorbent. I find this paper difficult to handle. The underlying paints tend to redissolve with subsequent glazes, resulting in a mixture of paints rather than a glaze.

Whatman watercolor papers bleed or feather to excess, even with the smallest amount of moisture. It is a good paper for techniques where feathering is desired. Once dry, Whatman appears a little dull in comparison to a paper like Arches. Like Artistico, the paper fibers also separate when scrubbed, and lifting the paints after they are dry is difficult on this surface.

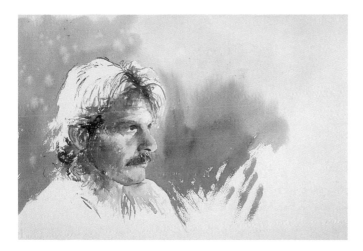

Truman 12″ × 18″ (31 × 46 cm)
Arches 140 lb. Cold Pressed

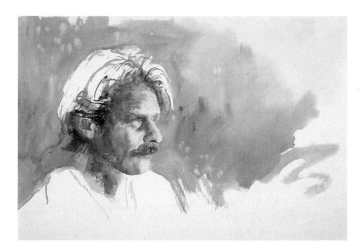

Truman 12″ × 18″ (31 × 46 cm)
Fabriano Artistico 140 lb.
Cold Pressed

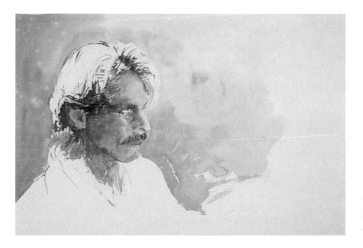

Truman 12″ × 18″ (31 × 46 cm)
Whatman 140 lb. Cold Pressed

WATERCOLOR PAPERS

The selection of papers for this book is based on three factors: availability, cost, and popularity. The availability of watercolor paper varies considerably from location to location. Catalogs from major artist supply houses can provide an adequate source for the materials available on the current market and those discussed in this book.

The cost of watercolor paper depends largely on weight, size, and physical properties and can range upward from $10.00 per sheet. This catalog will deal with papers of moderate cost. The average price for a 140 lb. (300 g/m²) 22″ × 30″ (56 × 76 cm) sheet of watercolor paper is between $2.00 and $3.00. Paper in this price range is usually of good quality and meets the standards considered essential by the serious artist.

Several major paper manufacturers have consistently provided the art community with high-quality, readily available, moderately priced watercolor papers. Most of the papers discussed in this book are distributed by companies including, but not limited to Arches, Fabriano, Lanaquarelle, Strathmore, T. H. Saunders, and Whatman.

Recently introduced to the market is Windsor & Newton watercolor paper. The top market share of watercolor paper is undoubtedly held by Arches of France. Recently, Strathmore, Lanaquarelle, and Fabriano have also become favorite choices for watercolor painters.

Each paper in this book is described by a listing of specific properties, a discussion of paper characteristics, and a representative work completed on the paper under discussion.

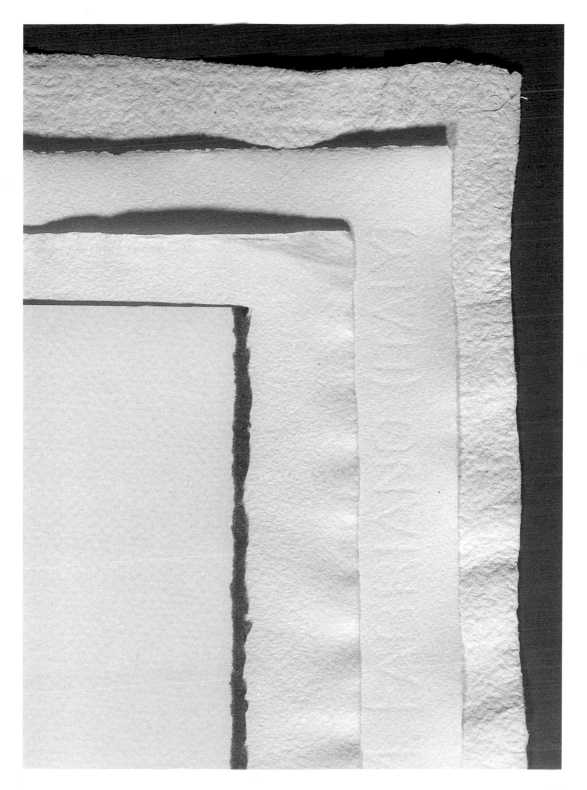

Arches 140 lb. Cold Pressed

Fiber Content: 100% rag
Surface Texture: Cold pressed
Weight: 140 lb. (300 g/m²)
Color: White
Size: 22″ × 30″ (56 × 76 cm) to 40″ × 60″ (102 × 152 cm). Also available in blocks from 9″ × 12″ (23 × 30 cm) to 18″ × 24″ (46 × 61 cm) as well as rolls
Price Range: $2.15 to $2.65 per 22″ × 30″ sheet
Absorbency: Slight
Reworkability: Good
Watermark: Arches France
Sizing: Hard

This mediumweight paper lends itself to all traditional techniques in Western watercolor painting, from the broadest washes to the most intimate details.

The Arches Cold Pressed surface offers a variety of features that render this particular paper one of the easiest to control. Because it is sized externally, with a very hard sizing, it allows paint to be evenly distributed, as well as altered. The surface will also take substantial abuse in the form of scrubbing and scraping. If the surface sizing is removed by scraping and the paper fibers are exposed, however, the fibers will act as a blotter. Watercolor pigments absorbed into the exposed areas appear darker than those on the surface where the sizing is intact. Scrubbing alone, as with a bristle brush, will not remove the surface sizing even if the paper has been soaked for a long period of time.

Because it is a hard-sized paper, its surface is not very absorbent, and dark values are difficult to obtain. If large amounts of pigments are applied to this surface, they may appear muddy once dry, but this can be corrected by lifting the excess paint with a dry tissue or sponge.

This hard sizing also inhibits the flow of paint into the fibers (process of capillary action), and consequently it reduces the formation of capillary ridges. Capillary ridges (hard edges of paint) are formed when pigment is absorbed into the paper fibers and dries unevenly, leaving concentrated color at the edge of the wetted surface.

Modeling and smooth transitions are easily accomplished on Arches Cold Pressed. Glazing is one of the techniques that can be repeated time and time again without lifting the underlying paints.

All watercolor papers made from natural fibers will buckle during the painting process if large washes are applied. Unlike many other supports, Arches Cold Pressed will flatten after a few weeks of horizontal storage.

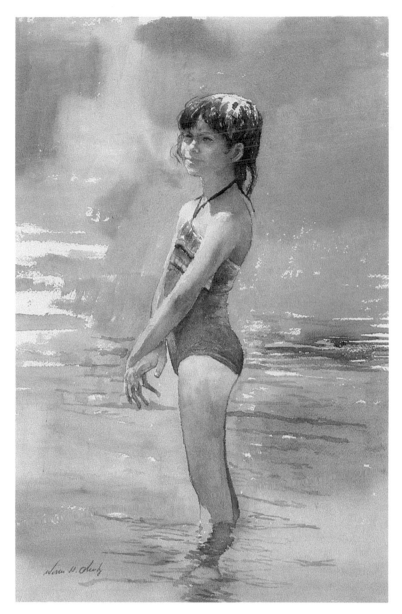

Gina 18" × 12" (46 × 30 cm)
Arches 140 lb. Cold Pressed

Arches 140 lb. Cold Pressed is probably the most popular watercolor paper on the market. Its hard sizing and moderate texture makes Arches Cold Pressed one of the most easily controlled papers. In addition to paint control, the paper can withstand scrubbing and scraping without the paper fibers coming apart.

Small paintings on the Arches Cold Pressed surface, however, are not particularly pleasing, as the texture of the paper seems to interfere with the image. When using a dry brush, the texture of the paper takes on a mechanical appearance. Although fine detail is possible on this surface, the texture has the upper hand.

Arches 140 lb. Hot Pressed

Fiber Content: 100% rag
Surface Texture: Hot pressed
Weight: 140 lb. (300 g/m$_2$)
Color: White
Size: 22″ × 30″ (56 × 76 cm) to 40″ × 60″ (102 × 152 cm). Also available in blocks from 9″ × 12″ (23 × 30 cm) to 18″ × 24″ (46 × 61 cm) as well as rolls
Price Range: $2.15 to $2.65 per 22″ × 30″ sheet
Absorbency: Very slight
Reworkability: Poor
Watermark: Arches France
Sizing: Hard

The hard sizing and smooth surface of this paper makes this one of the least absorbent watercolor papers. Soft edges are difficult to achieve on this support, as are broad, even washes. Capillary action is slight and, if the paper is tipped at an acute angle when painting, the paints have a tendency to run.

Dry paintings are difficult to alter on Arches Hot Pressed. If a dry painting is rewetted, some of the pigments can be lifted, but I have been unable to lift all the paint off this surface.

All Arches watercolor papers can be scrubbed without changing the quality of the painting surface.

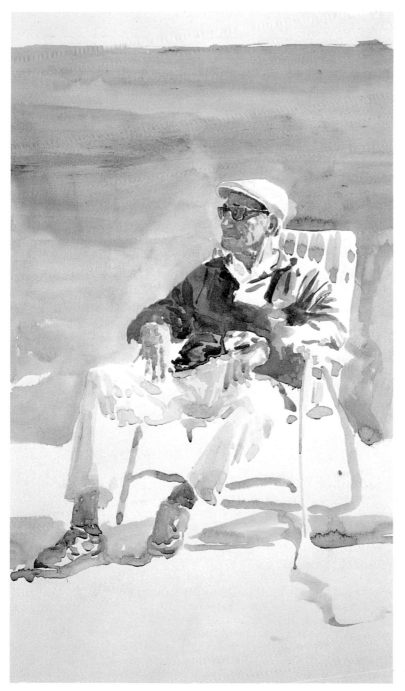

Joe 16″ × 18″ (41 × 46 cm)
Arches 140 lb. Hot Pressed

Small paintings on this smooth, hard surface are difficult. The surface has little absorbency, and controlling fine lines, even with a fairly dry brush, requires a delicate touch. Paintings on it that are larger are much easier to control.

Arches 140 lb. Rough

Fiber Content: 100% rag
Surface Texture: Rough
Weight: 140 lb. (300 g/m²)
Color: White
Size: 22″ × 30″ (56 × 76 cm) to 40″ × 60″ (102 × 152 cm). Also available in blocks from 9″ × 12″ (23 × 30 cm) to 18″ × 24″ (46 × 61 cm) as well as rolls
Price Range: $2.15 to $2.65 per 22″ × 30″ sheet
Absorbency: Slight
Reworkability: Good
Watermark: Arches France
Sizing: Hard

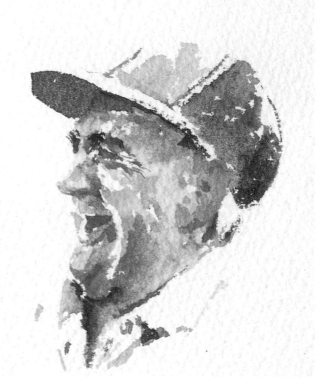

The surface of Arches 140 lb. Rough is remarkably well suited for detail, as well as control of watercolor paints. The surface is hard-sized and not very absorbent. Even transitions of paints can be easily achieved on this surface.

The rough surface is an excellent tool for the watercolor painter who utilizes such techniques as scrubbing and scraping. This surface will take an extraordinary amount of scrubbing without destroying the paper's composition. Highlighting areas of a watercolor painting by scraping is thus easily accomplished on this support. When dry, the watercolor pigments on the surface can be scraped off with a knife or razor blade. The surface can also be sanded to lighten areas.

Arches Rough watercolor papers are well suited for sanding. Sanding should be done on a dry and flat surface. If the surface is wet during sanding, the sandpaper may tear the paper fibers, making the paper unsuitable for painting. Controlling the amount of sizing or pigment to be removed is quite easy on Arches Rough.

When the sizing on the surface is removed by scraping or sanding, the unsized paper fibers underneath are very absorbent. Repainting the area will let the watercolor pigments soak into the paper fibers, and the resulting color areas are much deeper in value.

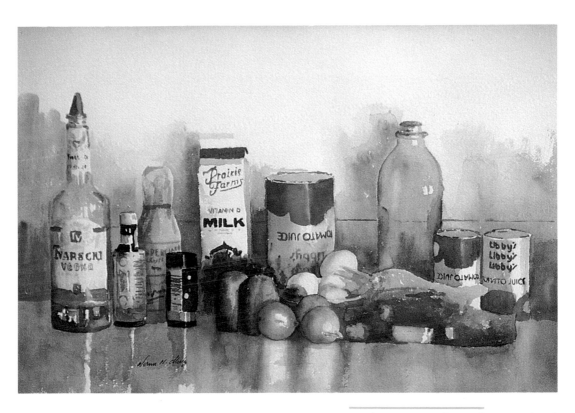

Sunday Morning 14″ × 22″ (36 × 56 cm)
Arches 140 lb. Rough

It may sound contradictory but I have always found that Arches Rough
watercolor paper shows a higher degree of detail than the Arches Cold or Hot
Pressed surfaces, as long as the light falling on the paper does not enhance
the surface texture. The Rough surface is one of the best watercolor supports
for controlling watercolor paints. Smooth transitions, as well as the ability to
lift excess paint, are easily achieved. It is a hard-sized surface that can take a
substantial amount of abuse without the paper fibers coming apart.

Arches Liberté

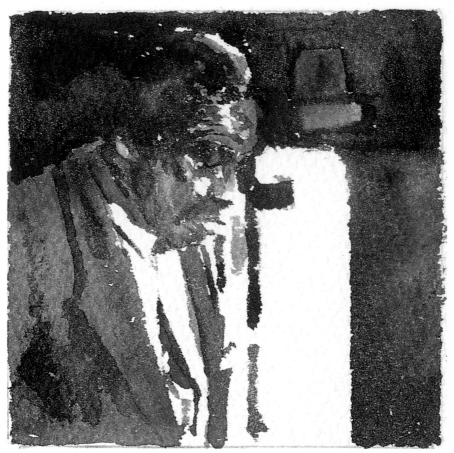

Fiber Content: Synthetic and rag
Surface Texture: Not rated
Weight: 80 lb. (170 g/m²)
Color: White
Size: 22″ × 30″ (56 × 76 cm). Also available in 9″ × 12″ (23 × 30 cm) pads
Price Range: $1.65 to $2.25
Absorbency: Slight
Reworkability: Good
Watermark: None
Sizing: Hard

A combination of synthetic and natural fibers makes Arches Liberté less prone to buckling. Unless a completely flat painting surface is desired, stretching this watercolor paper is not necessary. Absorption is minimal, and watercolor paints tend to flow very quickly. Broad, even washes can be accomplished with relative ease, but if the painting is tilted at a high angle, the watercolors may run uncontrollably.

Although Liberté is a lightweight watercolor paper, it will take reworking without altering the paint surface. Capillary ridges are distinct, and, if the painting is large, they are almost a certainty. This support, once dry, is difficult to alter, but the surface can take abuse; sanding and scraping do not tear this paper easily.

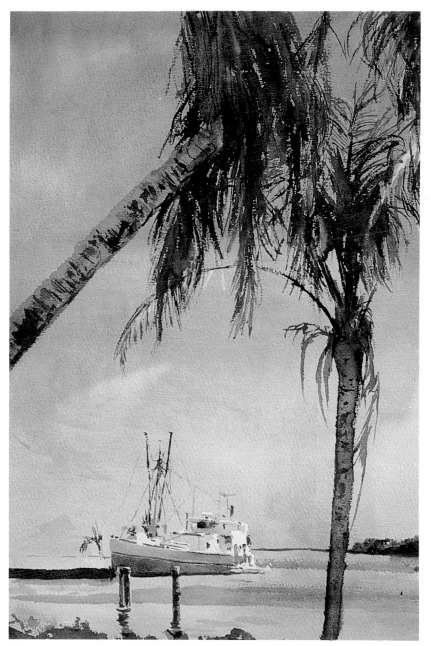

Bimini 24″ × 16″
(61 × 41 cm)
Arches Liberté 80 lb.

It's seldom that I have the opportunity to use very bright colors for the sky, as in this painting. But, being set in the Bahamas, this sky reflects a naturally bright blue. Liberté lends itself to the use of bright colors, as the paints sit on the surface.

Fabriano Artistico 140 lb. Cold Pressed

Fiber Content: 100% rag
Surface Texture: Cold pressed
Weight: 140 lb. (300 g/m²)
Color: White
Size: 22″ × 30″ (56 × 76 cm). Also available in blocks
Price Range: $1.95 to $2.75
Absorbency: Moderate
Reworkability: Poor
Watermark: C M Fabriano 100/100 Cotton
Sizing: Light

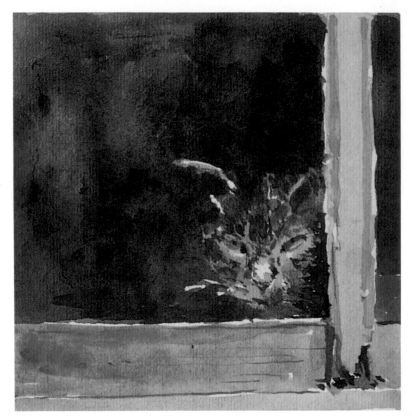

The surface of Fabriano Artistico 140 lb. Cold Pressed paper is unique. It is the only watercolor support with a surface that can be classified as somewhere between laid and wove. The surface consists of a minute square pattern resembling a laid paper, but the small irregularities in the pattern suggest a wove paper.

The surface of Fabriano Artistico Cold Pressed paper can hold a substantial amount of pigment without losing the luster and translucency found only in watercolor painting.

Artistico is more absorbent than most watercolor papers, therefore smooth transitions of paint can be difficult. Once the paint is absorbed into the paper, the paint is hard to manipulate, and if allowed to dry, it becomes impossible to change merely by rewetting. Deep values can be obtained by overloading the surface with pigments. Excess pigment can be lifted with a dry brush or sponge.

To alter a dry painting on Artistico, drastic measures have to be taken. Artistico is absorbent because the paper is not heavily sized, and when wet, the paper fibers separate rather easily. This is the physical phenomenon that makes it possible to alter an already dry painting. It is possible to separate the paper fibers easily by wetting the area to be altered and scrubbing it with a bristle brush. As the desired amount of painted area is removed, small balls of paper fiber adhere to the surface. Once dry, the paper balls can be removed with a dry sponge or towel and painting can be resumed. The area where the paper fibers are removed becomes slightly more absorbent than the surrounding area.

Artistico is prone to buckling, but if this is objectionable, the paper can be stretched. There is a slight change in the physical properties after the paper has been stretched: The absorbency is enhanced, but this physical change is slight.

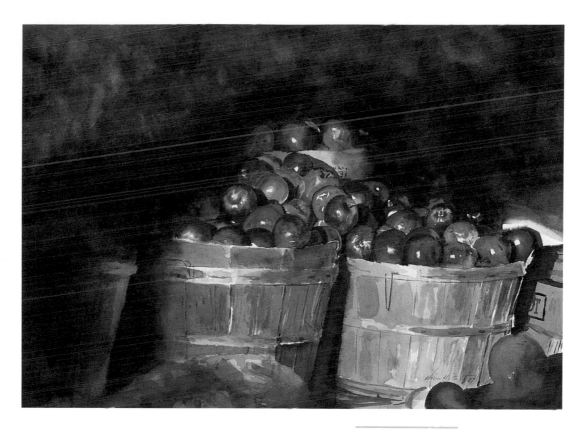

Apple Jack 14″ × 22″ (36 × 56 cm)
Fabriano Artistico 140 lb. Cold Pressed

I chose the Fabriano Artistico 140 lb. surface in order to achieve very dark values in the background of this painting. Being a moderately absorbent surface, a fair amount of control is possible. The paper will also absorb enough pigments to obtain dark values.

Fabriano Artistico 140 lb. Hot Pressed

Fiber Content: 100% rag
Surface Texture: Hot
 pressed
Weight: 140 lb. (300 g/m²)
Color: White
Size: 22″ × 30″ (56 ×
 76 cm). Also available in
 blocks
Price Range: $1.95 to $2.75
Absorbency: Very good
Reworkability: Poor
Watermark: C M Fabriano
 100/100 Cotton
Sizing: Light

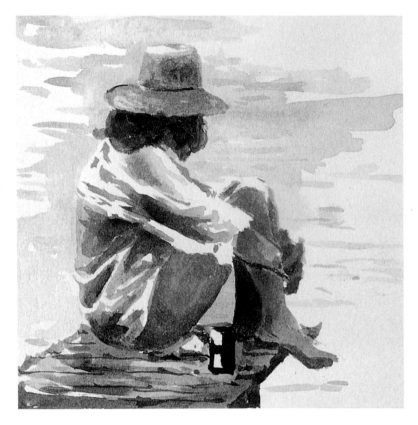

Hot-pressed surfaces are very smooth, thus controlling the flow of paint may be difficult. Because the sizing is not as hard as that of some watercolor papers, this paper is fairly absorbent and stains immediately when paint is applied. It is very difficult to lift or alter the paint once it is dry. Since this condition can create hard edges, painting on a wetted surface may help counter this effect.

The novice watercolor painter may find the Artistico Hot Pressed surface too challenging to control. A more experienced artist will find the surface a plus for many applications, particularly glazing. This technique allows subsequent layers of paints to be applied to the surface while maintaining transparency and luminosity. This absorbent paper is well-suited for this technique.

Close inspection of painted areas on this surface reveals minute granules of watercolor pigments resembling the grain structure of an enlarged photograph. The overall effect is thus unique and appealing.

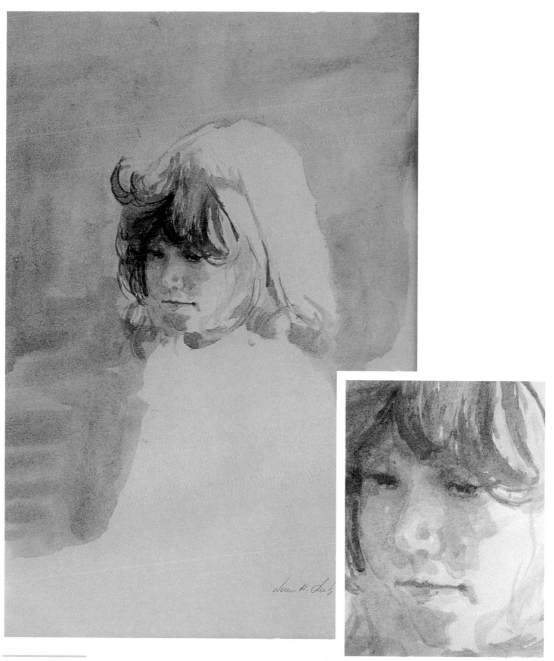

Rachel 18″ × 14″ (46 × 36 cm)
Fabriano Artistico 140 lb. Hot Pressed

Detail of Fabriano Artistico 140 lb.
Hot Pressed surface.

As smooth transitions can be difficult on most hot-pressed surfaces, this por-
trait of my daughter was begun in small sections. After the details were laid
in place, larger glazes were applied to link the values. Then the background
was painted with a very wet wash to avoid creating capillary ridges.

Fabriano Artistico 140 lb. Rough

Fiber Content: 100% rag
Surface Texture: Rough
Weight: 140 lb. (300 g/m²)
Color: White
Size: 22″ × 30″ (56 × 76 cm). Also available in blocks
Price Range: $2.45 to $3.79
Absorbency: Moderate
Reworkability: Fair
Watermark: C M Fabriano 100/100 Cotton
Sizing: Medium

The surface of Fabriano Artistico 140 lb. Rough is among the most textured of popular watercolor papers. Although very rough, it is not abrasive; however, the rough surface lends itself to a controlled wash, covering large areas. The sizing of Artistico Rough is harder than the surface of Artistico Cold Pressed, making it easier to manipulate the flow of paints. Smooth transitions of paint on the rough surface can be accomplished without any difficulty.

Alterations to a dry painting on this support are relatively simple. By rewetting the surface, the watercolor pigments can be manipulated or, if desired, removed with a dry sponge or tissue. Some watercolor paints, however, contain dyes that may stain the paper fibers. Once the paper fibers are dyed, alterations or removal of paint may not be possible.

In contrast to Artistico Cold Pressed paper, the Rough paper's surface will take a substantial amount of scrubbing without changing the physical nature of the surface. This in turn makes the surface suitable for portrait and figure studies or for any work in which smooth transitions of paint are desired.

Artistico 140 lb. Rough has one characteristic that can limit its use. The edges of each sheet undulate in a pattern of waves. The waves are impossible to remove by merely pressing the paper; the only solution is to stretch each sheet.

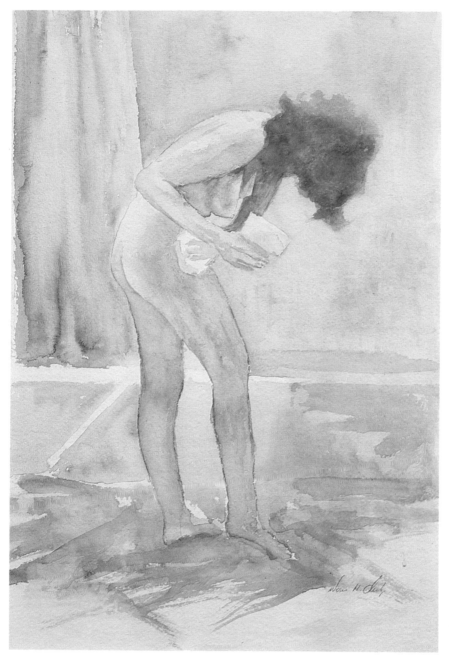

Fran 20″ × 14″
(51 × 36 cm)
Fabriano Artistico
Rough

The surface of Fabriano Artistico Rough is one of the most textured surfaces I have seen. Although the surface is very rough, this support will render detail without too much trouble. The Rough is sized harder than the Fabriano Cold or Hot Pressed. Smooth transition, as well as the ability to make corrections in the form of lifting paints and scraping, can be accomplished on the Rough surface.

Lanaquarelle 140 lb. Cold Pressed

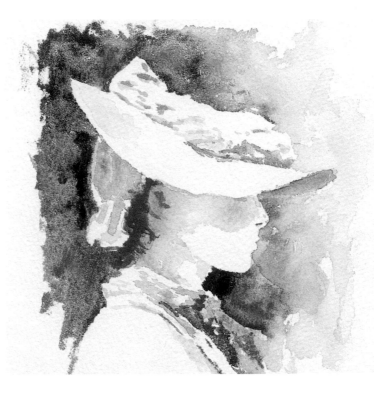

Fiber Content: 100% rag
Surface Texture: Cold pressed
Weight: 140 lb. (300 g/m²)
Color: White
Size: 22″ × 30″ (56 × 76 cm), 29″ × 41″ (74 × 104 cm)
Price Range: $1.85 to $3.00 per 22″ × 30″ sheet
Absorbency: Slight
Reworkability: Good
Watermark: Lanaquarelle
Sizing: Hard

Lanaquarelle is new on the market and is one of the easiest watercolor papers to control. The surface has an abrasive texture and is comparable to most other cold-pressed papers, having a slight mechanical appearance. The back surface is much smoother than the front and has the look and feel of a hot-pressed surface. The painting quality of the front and back side of this paper, however, is virtually the same. The texture of the front side will hold the watercolors a little longer, making it easier to manipulate the paints while they are wet.

Lanaquarelle is very white, but toward the warm side, and the colors are some of the brightest I have seen on watercolor paper. Besides having a very white surface, Lanaquarelle has a hard sizing, leaving the watercolors resting on top of the paper, thus insuring vivid colors. The paper dries much lighter than some of the more absorbent papers, and a single wash often results in a speckled effect. The speckled effect can be eliminated with a second wash or a bristle brush, but some may find the effect attractive.

Controlling the flow of paints when model-ing the values is relatively easy on Lanaquarelle. Once the paints are dry corrections can also be accomplished by rewetting the surface and lightly scrubbing excess paints to lift them. Removing paints by scratching is not easy to control, as the surface has a tendency to come off in small chunks. Another positive feature of this paper becomes apparent when painting wet on dry. As often happens with this technique, small amounts of concentrated pigment may be picked up by the brush, and, when applied to the dry paper, the concentrated pigments leave areas of much darker values than originally intended. On most papers these areas are difficult if not impossible to remove, but on Lanaquarelle they are easily incorporated into the painting with a small amount of scrubbing.

The many positive features of Lanaquarelle are not limited to techniques alone. Buckling is far less pronounced than on most papers, and, when dry, this support is remarkably flat. For the painter who desires a high degree of control, as well as a surface that can withstand scrubbing without falling apart, this is the paper to try.

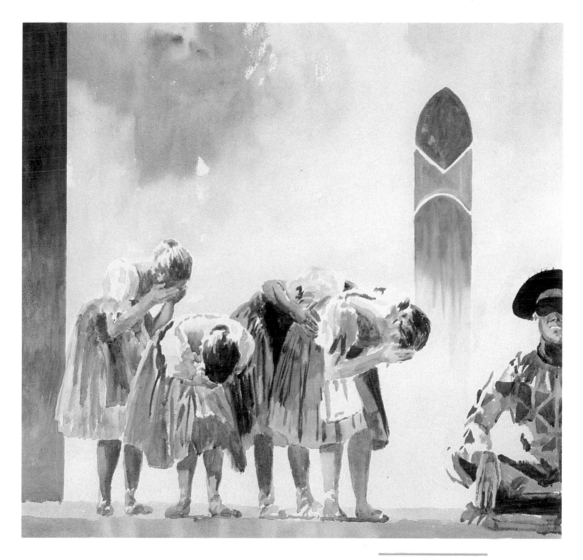

"Harlequin" 10″ × 19″ (25 × 48 cm)
Lanaquarelle 140 lb. Cold Pressed

This painting is a composite of two photographs from the Richmond Ballet production of Coppelia. *Local stage productions will usually provide permission to photograph performances, and these photographs make good sources for paintings.*

Although Lanaquarelle may be lighter in value when dry, figures are relatively easy to paint. Smooth transitions and glazes can both be achieved, but very deep values can be difficult.

Lanaquarelle 140 lb. Hot Pressed

Fiber Content: 100% rag
Surface Texture: Hot pressed
Weight: 140 lb. (300 g/m²)
Color: White
Size: 22″ × 30″ (56 × 76 cm), 29″ × 41″ (74 × 104 cm)
Price Range: $3.30 to $4.00 per 22″ × 30″ sheet
Absorbency: Slight
Reworkability: Good
Watermark: Lanaquarelle
Sizing: Very hard

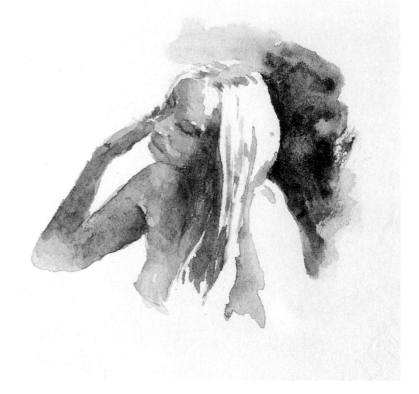

Unlike the Lanaquarelle Rough and Cold Pressed surface, I find the Hot Pressed hard to control. This surface is very smooth, almost as smooth as a bristol board with a plate finish. Absorption is kept to a minimum, making it difficult to obtain dark values of color. When additional color is added, the paper seems reluctant to accept more color.

The paper has a very hard sizing, but unlike other hot-pressed surfaces a smooth wash is fairly easy to obtain. Capillary ridges are not frequent, and when they do appear they are not very pronounced. Corrections, as in the form of lifting paints by rewetting the surface and absorbing the dissolved paints, can remove a substantial amount of pigment. The surface will take much abuse in the form of scrubbing. Although excessive scrubbing may lift some of the paper fibers, the surface will accept additional paint.

Scraping the surface, either wet or dry, must be done with care. The surface tends to come apart in rather large chunks, which is not appealing. But even though the surface may have been destroyed, either by scrubbing or scraping, additional washes of paint don't show the traditional telltale sign of a darker area where the surface had been altered. This leads me to believe that this paper (including Cold Pressed and Rough) is sized internally as well as externally.

Glazing techniques are not difficult on the Hot Pressed surface, but, as mentioned above, the surface is reluctant in receiving overlaying paints. When glazing, it is not enough to simply apply additional layers of paint. In order to get the lower values desired more pigment and less water should be used in the glaze.

The painters who enjoy a very hard and less absorbent surface that can be manipulated to a great extent may want to keep this surface in mind.

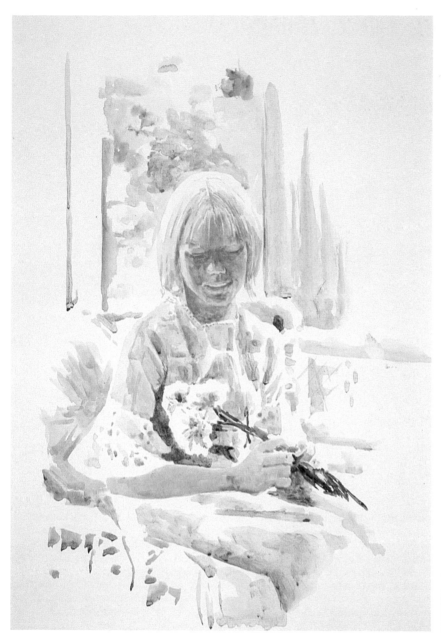

Spring 14″ × 24″
(36 × 61 cm)
Lanaquarelle 140 lb.
Hot Pressed.

Knowing that Lanaquarelle Hot Pressed was a very hard surface, making it difficult to portray deep values, I chose a very bright subject to paint.

Lanaquarelle 140 lb. Rough

Fiber Content: 100% rag
Surface Texture: Rough
Weight: 140 lb. (300 g/m²)
Color: White
Size: 22″ × 30″ (56 × 76 cm), 29″ × 41″ (74 × 104 cm)
Price Range: $1.85 to $3.00 per 22″ × 30″ sheet
Absorbency: Slight
Reworkability: Good
Watermark: Lanaquarelle
Sizing: Very hard

Like the 140 lb. Cold Pressed, the Lanaquarelle Rough surface is very easy to handle. The surface is not excessively rough, but it can hold a fair amount of water if the paper is on an angle while painting. Unlike the Lanaquarelle Cold Pressed surface, the Rough paper has a fair amount of texture on the reverse. There is, however, a difference between the front side and the back side of this support.

The sizing is very hard, leaving the paints on the surface. This in turn produces some of the most vivid and brilliant colors I have seen on a watercolor paper. The colors do not lose much of their original intensity as the paint dries, which can often happen with an absorbent paper.

This paper has two effects that I find quite attractive. The first is a speckled effect that occurs when applying a single wash. Some areas of the surface seem to repel the colors, leaving minute white dots within the wash. The speckled effect can be eliminated by either giving the area an additional wash or scrubbing with a hard brush. The second effect is an uneven pattern of paint that occurs when applying a semidry wash. This uneven pattern relieves the monotony of a flat, even wash, and, in such areas as clothing or buildings, the effect gives a little life to the painting. If a flat, even wash is desired, this can be accomplished by adding a little more water to the wash.

Transitions of paints as well as controlling values are very easy on this surface. As the paints remain on top of the paper in ample amounts of moisture, the paints can be manipulated for an extended period of time. Once dry, some of the paints can be removed by rewetting the surface and scrubbing the area with a bristle brush, then lifting the paints with a dry tissue or brush.

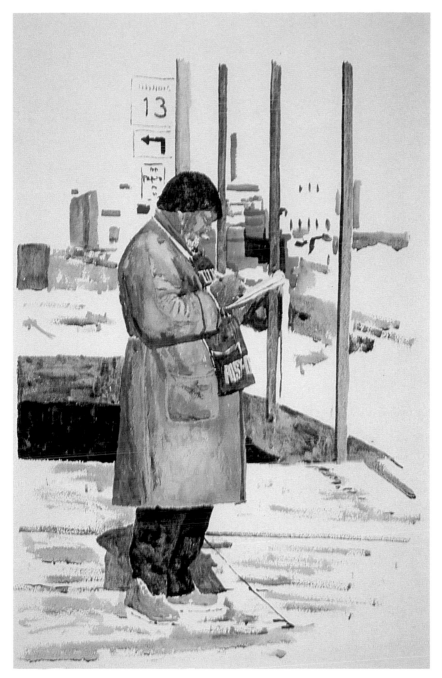

Truman 16″ × 26″
(41 × 66 cm)
Lanaquarelle 140 lb.
Rough

*Truman supposedly could neither read nor write but each morning he would
go through the* Racing Form *in front of the spot where he sold newspapers.
Lanaquarelle Rough provided a delightful pattern for Truman's not-so-neat
clothing.*

Magnani Acqueforti

Fiber Content: 100% rag
Surface Texture: Cold
 pressed
Weight: 140 lb. (300 g/m²)
Color: White
Size: 22″ × 30″ (56 ×
 76 cm)
Price Range: $2.25 to
 $3.45
Absorbency: High
Reworkability: Poor
Watermark: Magnani logo
Sizing: Negligible

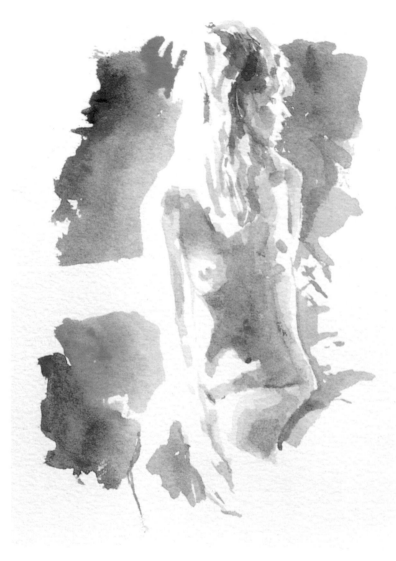

Acqueforti is a very absorbent paper; controlling the flow of paints on this surface is practically impossible. When a fair amount of paint is applied to the surface the paint is absorbed and begins to travel. This movement of paint is unlike feathering, in which the intensity of the colors decrease as the paints spread. Acqueforti behaves more like a blotter, as the paints keep an even value as they spread.

The surface resembles a laid paper with a very fine grid pattern. This pattern does not seem to interfere with any image painted, as the pattern is so fine that it is hardly noticeable.

Having little or no sizing, Magnani Acqueforti watercolor paper is not very receptive to any form of heavy scrubbing or scraping.

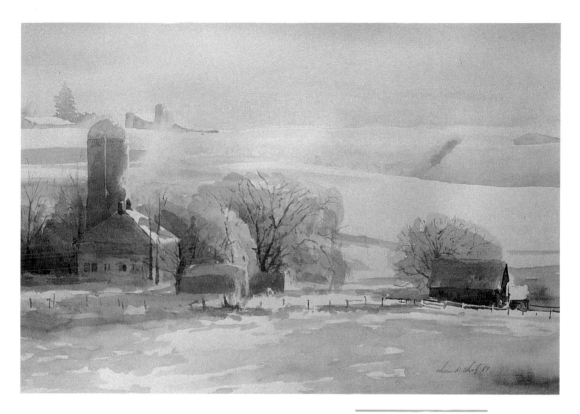

Winter Morning 18″ × 26″ (46 × 66 cm)
Magnani Acqueforti

*In order to gain some control of paints on this paper, I sized a few sheets
with gelatin. The resulting paint surface was excellent, and the illustration
for this paper was painted on the sized surface.*

Magnani Acquerello

Fiber Content: 100% rag
Surface Texture: Cold
 pressed
Weight: 120 lb. (280 g/m²)
Color: White
Size: 19″ × 27″ (48 ×
 69 cm), 22″ × 30″ (56 ×
 76 cm)
Price Range: $2.35 to
 $3.90 per 22″ × 30″
 sheet
Absorbency: Moderate
Reworkability: Poor
Watermark: Magnani logo
Sizing: Light

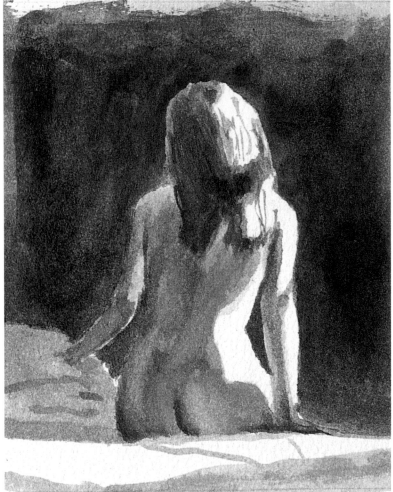

The surface of Acquerello has less texture than most other papers rated as cold pressed. It is soft to the touch, and the texture is without bias.

Broad, even washes are difficult when painting wet on dry, as this paper is fairly absorbent. When paints are applied with an ample amount of water, the paints will spread. This effect is unlike feathering. Obtaining a graded wash covering a small area is difficult, as the paint values tend to even out unless applied in a drybrush manner. Although paints will spread on this surface, they do not spread excessively as on Magnani Acqueforti.

Deep values can be achieved on this surface, but the paints should be applied in a single wash. This paper is not very receptive to subsequent washes, as these washes seem to spread even more with additional applications of paint.

Creating highlights by scraping must be done with a gentle touch. The soft paper tends to come apart with heavy scraping or scrubbing whether the surface is wet or dry.

Still Life 14″ × 20″ (36 × 51 cm)
Magnani Acquerello

Being a moderately absorbent paper, Magnani Acquerello is a good recipient for dark values. But smooth transitions and modeling of colors can be difficult. In addition, the surface will not take much abuse. When wet, the surface will come apart with light scrubbing or scraping.

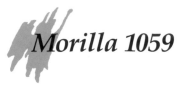

Morilla 1059

Fiber Content: Some rag content
Surface Texture: Not rated
Weight: 140 lb. (300 g/m²)
Color: White
Size: 22″ × 30″ (56 × 76 cm). Also available in rolls
Price Range: $1.25 to $1.45
Absorbency: Slight
Reworkability: Excellent
Watermark: None
Sizing: Very hard

Morilla 1059 is referred to as a student-grade paper recommended as a practice support. This is an unfortunate recommendation, as it takes a skilled hand and a fair amount of knowledge about watercolor painting to have some control when painting on this surface.

The surface of Morilla 1059 is unusual, although it does resemble Fabriano Artistico Rough. I would classify the Morilla 1059 surface as hot pressed with irregular undulations. The distance between the peaks and valleys of this irregular surface is so great that it is hard to say whether it really has a particular texture. The surface itself is very smooth, and the texture is created by minute rolling hills. The back side of Morilla is as smooth as a true hot-pressed surface, but I find painting on the smooth side even more difficult than on the textured side.

Achieving an even watercolor wash, or one of graded value, is very difficult on this support, as the paper has the tendency to dry unevenly, and at times the paper seems to repel the watercolors randomly. The sizing is probably glue. Glue sizing adheres much better to masking tape than paper sized with gelatin; if Morilla 1059 is taped,

the surface will tear when the tape is removed.

The sizing is very hard, in fact, so hard that watercolors sit high on the surface. Unfortunately, the watercolors will lift so easily when dry that glazing techniques are practically impossible. Underlying paints will dissolve when glaze is applied, and true colors, as well as detail, will be lost.

Obtaining deep values on this paper is very difficult. Because the paints sit high on the paper, when dry the colors are quite a bit lighter than the original application. In order to achieve deep values it is necessary to use a fairly drybrush, overloaded with pigment, and apply the paints in a single application.

Controlling a graded wash is also difficult on this surface, as the watercolor paints dilute too easily. This dilution simply unifies the color values. Smaller paintings are simpler to control, as the surface is quite smooth and drybrush techniques can be used to obtain deep values.

For the novice watercolor painter I would hesitate to recommend Morilla 1059, even as a practice paper, as it may act more as a deterrent rather than a positive learning experience.

Uncertain Weather 14″ × 20″ (36 × 51 cm)
Morilla 1059

*This hard-sized surface is difficult to handle. As glazes were applied in this
painting, the underlying paints kept dissolving, which mixed the colors.
Rather than achieving bright, vivid colors, the hues took on a muted
appearance.*

Strathmore Aquarius II

Fiber Content: Cotton and synthetic
Surface Texture: Not rated
Weight: 80 lb. (170 g/m²)
Color: White
Size: 22″ × 30″ (56 × 76 cm). Also available in 12-sheet pads
Price Range: $1.90 to $3.10
Absorbency: Moderate
Reworkability: Good
Watermark: None. Embossed in corner with Strathmore logo
Sizing: Hard

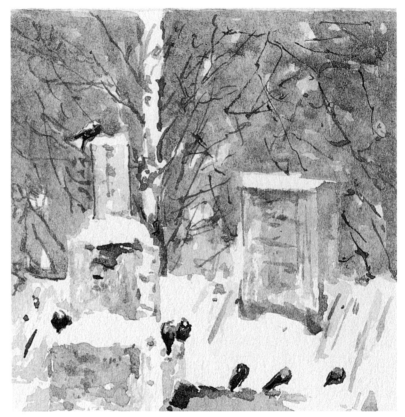

Although most good quality watercolor papers have a 100 percent rag content, some good synthetic papers have been introduced on the market in recent years. Aquarius II is one such paper.

This watercolor paper eliminates buckling, a common problem associated with all rag papers. The combination of synthetic fiber and rag used in producing this paper has been perfected to such an extent that no matter how much water is incorporated while painting, the paper remains flat.

The light weight of Aquarius II is deceiving. This paper is tough and durable. Heavy scrubbing of wet paint will not dissolve or easily tear the painting surface.

Capillary action on Aquarius II is not excessive, but capillary ridges are pronounced. This effect can be used to the painter's advantage.

The fairly smooth surface lends itself well to preliminary drawings with pencil or Conté crayon. During periods of high humidity, however, the paper becomes quite soft and reluctant to receive pencil or crayon.

Aquarius II is whiter than most other watercolor papers. Paintings on it are brilliant, and the colors are vivid and clear. Transparent washes and glazes are especially vivid on this paper.

Aquarius II is the only paper that remains flat during the painting process, and it remains flat when dry. Aquarius II is a good paper for those objecting to buckling or stretching.

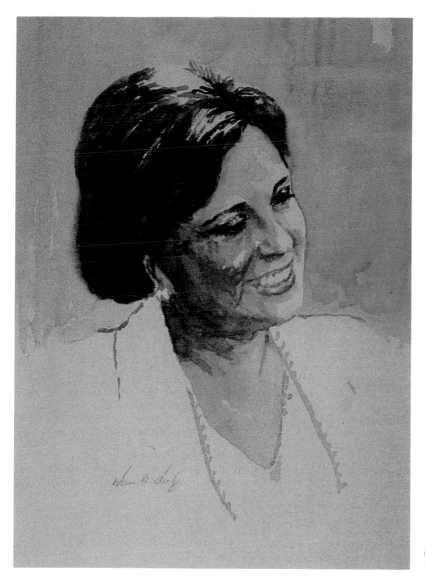

Jehan Sadat 20″ × 15″
(51 × 38 cm)
Strathmore Aquarius II

As a photographer at Radford University, I met Jehan Sadat at a news conference. The illustration here, reproduced in Rudford University Magazine, was from a photograph I took at the conference. I chose Aquarius II as a support, as the paper will produce capillary ridges. This effect can be used as an accent not only in portraiture, but for other paintings as well.

Strathmore Gemini 140 lb. Cold Pressed

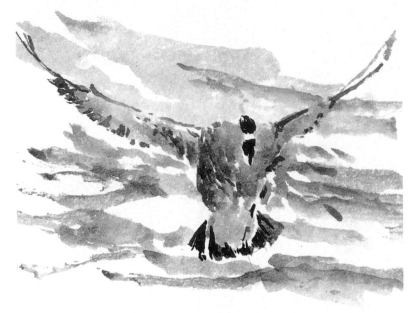

Fiber Content: 100% rag
Surface Texture: Cold
 pressed
Weight: 140 lb. (300 g/m²)
Color: White
Size: 22″ × 30″ (56 ×
 76 cm). Also available in
 blocks
Price Range: $3.11 to $3.95
Absorbency: High
Reworkability: Fair
Watermark: None.
 Embossed with
 Strathmore Gemini
 694-6
Sizing: Moderate-weak

There is quite a difference between the Cold Pressed and the Rough surfaces of Gemini. The Cold Pressed surface is definitely far less textured than the Rough, but the real difference is found in the drying process. On the Rough surface the colors are quite true when dry, but on the Cold Pressed support, the colors dry much lighter than when the paints are initially applied.

Landscape painters who rely on atmospheric distance in their paintings will find Gemini Cold Pressed an excellent provider of this effect. Smooth transition of paints is difficult on this surface, but Gemini Cold Pressed can take quite an amount of scrubbing, and soft edges are possible as long as the paints are not totally dry. Once dry the paints cannot be lifted easily but the paints can be removed by scraping. The areas scraped, however, do not provide a good paint surface, as the areas become even more absorbent than they already are.

Home Stretch 14" × 21" (36 × 53 cm)
Strathmore Gemini 140 lb. Cold Pressed

In this illustration I had a difficult time obtaining good color saturation. As soon as the paints were dry they looked more like ghost images than watercolor paints. I used this effect to create distance in the painting, as the lighter values give the impression of receding. By painting the horses in the back field with diluted black paint and relying on the paper to provide lighter values as it dried, the illusion of distance is easily created. It was necessary to give the front horse three layers of watercolor in order to obtain values deep enough to carry the rest of the painting.

Strathmore Gemini 140 lb. Hot Pressed

Fiber Content: 100% rag
Surface Texture: Hot pressed
Weight: 140 lb. (300 g/m²)
Color: White
Size: 22″ × 30″ (56 × 76 cm). Also available in blocks
Price Range: $3.11 to $3.95
Absorbency: High
Reworkability: Very poor
Watermark: None. Embossed with Strathmore Gemini 694-9
Sizing: Weak

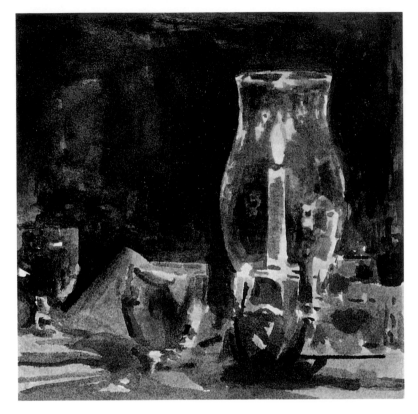

The difference between Gemini Hot Pressed and other hot-pressed watercolor papers is substantial. Generally, hot-pressed surfaces are not very absorbent; however, Gemini Hot Pressed is the most absorbent surface I have worked on. The painting qualities are similar to a mounted, unsized oriental paper, but being a 140 lb. paper Gemini can take far more working.

Corrections on this hot-pressed surface are practically impossible As soon as the watercolors are applied to a dry surface they are absorbed and manipulation of the paints is not possible. Scrubbing the surface only results in the paper fibers coming apart, leaving the scrubbed area rough and unsuitable for any additional painting.

Colors on Gemini Hot-Pressed tend to lose their clarity as the paints dry, undoubtedly due to the paper's great absorption, and colors dark in value tend to appear washed out.

Painting wet on wet presents another problem, namely excessive feathering. When watercolors are applied to a wet surface the pigments begin to travel, and this bleeding is very hard to control. In addition to excessive feathering, the Gemini line also buckles in a wave-like pattern, suggesting a grain direction in the paper, that creates valleys where excess watercolors will gather, which in turn results in bleeding.

Thought 12″ × 12″ (30 × 30 cm)
Strathmore Gemini 140 lb. Hot Pressed

*As it is difficult to create detail on the Gemini Hot Pressed surface, I used
pen and ink around the eyes in this painting. The pen often caught some of
the surface fibers, which came off the surface, and I had to remove the fibers
from the pen tip by hand.*

Strathmore Gemini 140 lb. Rough

Fiber Content: 100% rag
Surface Texture: Rough
Weight: 140 lb. (300 g/m²)
Color: White
Size: 22″ × 30″ (56 × 76 cm). Also available in blocks
Price Range: $3.11 to $3.95
Absorbency: High
Reworkability: Poor
Watermark: None. Embossed with Strathmore Gemini 694-3
Sizing: Weak

If texture is what a watercolor painter is looking for, then Gemini Rough is the paper to try. The surface is practically devoid of any mechanical appearance, and although the texture is pronounced, it is soft to the touch. The absorption rate is quite high, and, unlike a tub-sized paper, the texture of Gemini does not function well in regard to its ability to hold water on the surface of the paper. This paper is a great recipient for the drybrush technique, as the texture can be utilized in the painting process. Small paintings are not easy on Gemini Rough, as the texture seems to dominate the final product.

The high absorbency does not prevent colors from drying vivid and true, but lifting colors is very difficult as this paper is probably sized internally. Once the paints are dry glazing is an easy process.

Gemini Rough has excellent wet strength, and techniques such as scraping and scrubbing can be accomplished without fear that the surface will fall apart. Scraping should be done with a gentle hand as the surface may come off in large chunks, especially when wet.

Tall Tales 20″ × 18″ (51 × 46 cm)
Strathmore Gemini 140 lb. Rough

*The illustration on this paper gave me the opportunity to paint the three re-
ceding figures, in primary colors, on top of one another without any of the
colors lifting in the process.*

Strathmore Imperial 500 140 lb. Cold Pressed

Fiber Content: 100% rag
Surface Texture: Cold pressed
Weight: 140 lb. (300 g/m²)
Color: White
Size: 22″ × 30″ (56 × 76 cm)
Price Range: $2.95 to $3.95
Absorbency: High
Reworkability: Poor
Watermark: None. Embossed with Strathmore logo and 140-2
Sizing: Weak

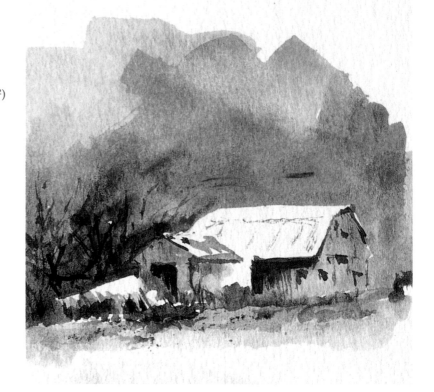

There is virtually no difference between the Cold Pressed and Rough surfaces of Imperial 500. The textures are virtually identical, as are the painting qualities. Telling the two apart is difficult unless they are placed next to each other.

Like the Rough surface, the Cold Pressed is very hard to control when painting figures, as soft edges and smooth transitions can only be achieved by painting wet into wet or by scrubbing with a hard brush. Although using opaque colors is not considered pure watercolor, it is a solution to many problems with this paper.

The Cold Pressed and Rough surfaces are quite absorbent and are good recipients for the drybrush technique. Dragging a fairly drybrush loaded with pigment across the textured surface of these papers produces an attractive paint texture that can be utilized to accentuate objects such as buildings, flowers, and clothing or whatever other texture is desired.

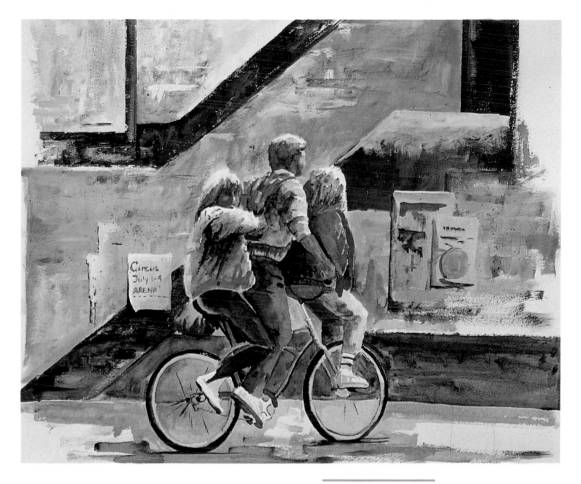

Spring Break 21″ × 21″ (53 × 53 cm)
Strathmore Imperial 500 140 lb. Cold Pressed

Once in a while I find it necessary to use opaque paints; Strathmore Imperial 500 Cold Pressed and Rough are excellent recipients for opaque applications. Glazing over the opaque paints is not a problem as the underlying paints are reluctant to lift.

Painting multiple figures, as in this illustration, can be controlled better with opaque paints than transparent ones, as mistakes can be hidden with additional applications of paint.

Strathmore Imperial 500 140 lb. Hot Pressed

Fiber Content: 100% rag
Surface Texture: Hot
 pressed
Weight: 140 lb. (300 g/m²)
Color: White
Size: 22″ × 30″ (56 ×
 76 cm)
Price Range: $2.95 to
 $3.95
Absorbency: High
Reworkability: Poor
Watermark: None.
 Embossed with
 Strathmore logo and
 140-3
Sizing: Weak

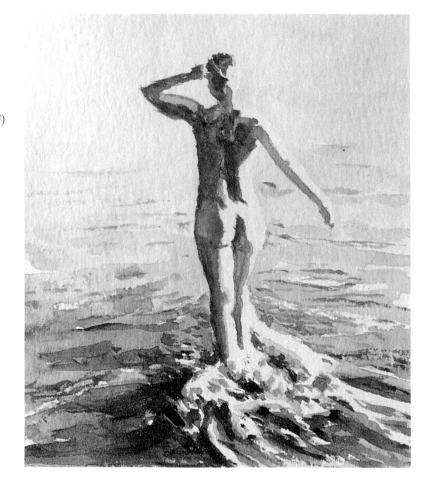

The absorbency of Imperial 500 holds true for the Hot Pressed surface also. Unlike most hot-pressed watercolor papers, which tend to suppress the absorption of water, Imperial is quite absorbent. The paper will also resist attempts to make colors run. Adding more water and color only results in the colors coming together into a unified value. Like the two other Imperial 500 surfaces, the Hot Pressed can take a substantial amount of abuse. Excessive scrubbing while the paper is wet, will loosen fibers.

Lifting dry watercolors are a little more difficult on the Hot Pressed surface than other surfaces classified the same. This in turn makes the Hot Pressed surface well suited for glazing and layering substantial amounts of pigments without the colors becoming muddy. Vivid colors and deep values are easy to obtain on any of the Imperial surfaces, but the colors seem particularly vivid on the Hot Pressed support.

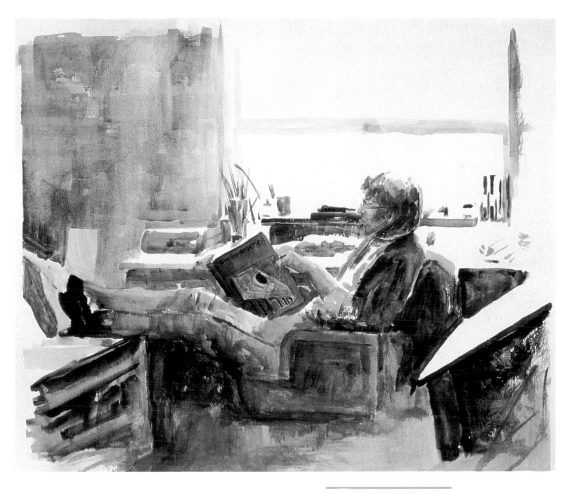

Art in America 17″ × 20″ (43 × 51 cm)
Strathmore Imperial 500 140 lb. Hot Pressed

In the illustration for this paper I wanted the background to be wet and flow-
ing. But, being an absorbent paper, the colors were reluctant to run. Unlike
a hard-sized, smooth surface, Imperial 500 is reluctant to give the painter
capillary ridges and a quick flow of paints.

Strathmore Imperial 500 140 lb. Rough

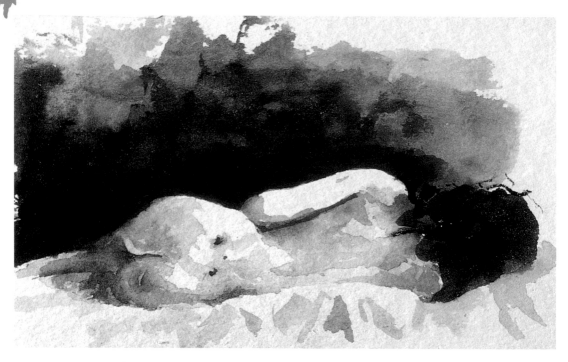

Fiber Content: 100% rag
Surface Texture: Rough
Weight: 140 lb. (300 g/m²)
Color: White
Size: 22″ × 30″ (56 × 76 cm)
Price Range: $2.95 to $3.95

Absorbency: High
Reworkability: Poor
Watermark: None.
 Embossed with Strathmore
 logo and 140-1
Sizing: Weak

One of the major characteristics of Imperial 500 is its absorbency. When painting wet on dry hard edges, capillary ridges are quite pronounced and smooth transitions are difficult. The paper, however, is very suitable for scrubbing with a hard brush, making it possible to manipulate the paints without destroying the surface. Because it is sized internally the paper has the tendency to absorb the watercolor more readily than papers that are tub-sized.

Tub-sized papers are papers that have an external sizing. The sizing is applied to the paper after the sheet is formed and dried by immersing the sheet into a tub of sizing and hanging the sheets up to dry. This technique of sizing is rare today as it is both time and space consuming. Most modern machine-made papers have the sizing applied by spraying the sizing on the dried sheets. Some handmade papers are tub-sized in the old fashioned manner and this is reflected in the cost of the paper. When a paper is sized internally, the sizing has been added to the paper pulp and thus is incorporated in the paper when the sheet is formed.

Imperial 500 will hold a substantial amount of moisture and remain wet for a considerable time when totally saturated. This characteristic ensures the painter who paints wet into wet ample time to manipulate the watercolors.

The rough surface does not feel as abrasive as a tub-sized paper nor is the texture excessively rough. The surface has a slight mechanical appearance that becomes more evident with the onset of painting. As with many other rough surfaces, it is difficult to control detail without the texture interfering. Peculiar as it may seem, scraping this moderately textured paper is fairly easy.

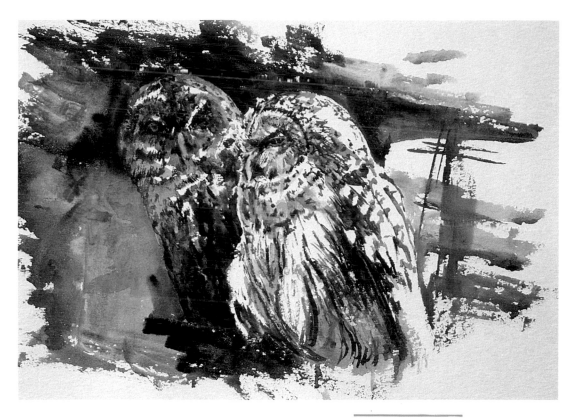

Barred Owls 9″ × 12″ (23 × 31 cm)
Strathmore Imperial 500 140 lb. Rough

I often use a watercolor paper with a rough surface when painting animals that have pronounced plumage or fur. The texture can be used to accent dry-brush techniques by dragging the brush across the surface. Imperial 500 Rough has a slightly mechanical surface appearance when drybrush is used, but it is not so severe as to impose on the final painting.

Utrecht 140 lb. Cold Pressed

Fiber Content: 100% rag
Surface Texture: Cold
 pressed
Weight: 140 lb. (300 g/m²)
Color: Off-white
Size: 11″ × 17″ (28 ×
 43 cm), 18″ × 24″
 (46 × 61 cm), 22″ × 30″
 (56 × 76 cm)
Price Range: $2.15 to $3.90
Absorbency: Low
Reworkability: Poor
Watermark: None.
 Embossed with Utrecht,
 100% Rag, Holland
Sizing: Medium

My immediate impression of Utrecht 140 lb. Cold Pressed watercolor paper was not positive. The color is an off-white and the texture appears quite mechanical, with a texture similar to papers graded as student-grade.

The sizing is apparently not the traditional hard sizing found in better-grade watercolor papers. The sizing is probably glue, as the sizing readily dissolves when scrubbed. Paints can be lifted easily on the Cold Pressed surface, but the surface sizing dissolves and the paints tend to move around, making smooth transitions difficult. Also, if the surface is scrubbed for any length of time, the fibers of the paper begin to separate and the scrubbed area seems a bit more absorbent when dry. Glazing can be done successfully, but only if the glazes are done quickly, as the underlying paints dissolve readily. If the

glaze is worked, even for a short time, the underlying colors will blend with the glaze, and the result will be a muddy appearance.

Although both Utrecht Cold Pressed and Hot Pressed surfaces may tear if masking tape is used, Utrecht Cold Pressed is still a tough paper. Scraping and sanding the paper when dry can be done without ruining the surface. If scraping, however, is carried out on a wet surface, there is a tendency for the paper to come out in chunks, and controlling the amount of paper to be removed can be tricky.

One surprising aspect, and a definite plus, of this paper is its resistance to buckling. Utrecht Cold and the Hot Pressed surfaces remain quite flat even after successive washes; the only paper I have tried that buckles less is Strathmore Aquarius II.

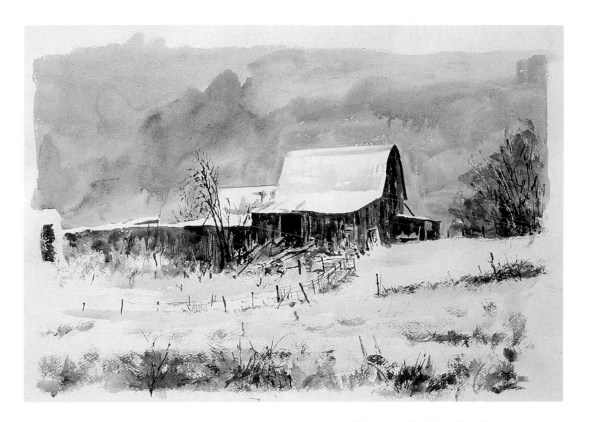

Winter Landscape 16″ × 24″ (41 × 61 cm)
Utrecht 140 lb. Cold Pressed

The Cold Pressed surface of Utrechts watercolor paper is not an attractive paper, nor a good watercolor receptor. Its reluctance to glazing techniques and smooth transitions of paint makes this surface somewhat limited.

Utrecht 140 lb. Hot Pressed

Fiber Content: 100% rag
Surface Texture: Hot
 pressed
Weight: 140 lb. (300 g/m²)
Color: White
Size: 11″ × 17″ (28 × 43 cm),
 18″ × 24″ (46 × 61 cm),
 22″ × 30″ (56 × 76 cm)
Price Range: $2.15 to $3.90
Absorbency: Low
Reworkability: Poor
Watermark: None.
 Embossed with Utrecht,
 100% Rag, Holland
Sizing: Medium

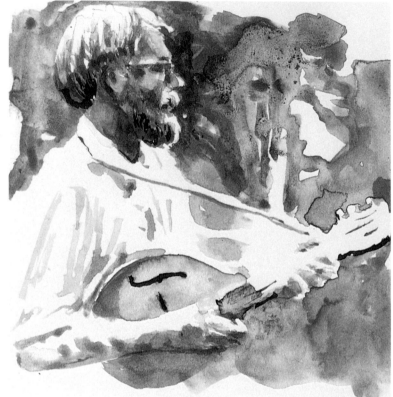

Visually, the Utrecht 140 lb. Hot Pressed surface is far more attractive than the Cold Pressed counterpart: it is whiter and also free from any mechanical surface texture.

The sizing feels and behaves similar to the Cold Pressed surface, but on the Hot Pressed surface the paints seem to move around in dissolved sizing even more. This is probably owing to the paper's lack of texture. Glazing is also more difficult on the Hot Pressed surface, as the underlying paints dissolve very quickly. If the glaze is

worked for even a short time, the end result is a lighter area rather than one of a lower value.

This surface will also separate with a minimal amount of scrubbing, leaving the scrubbed area with a granular appearance. Areas that have been subjected to scrubbing or washed become more absorbent after they have dried. The Hot Pressed surface lends itself well to scraping and to fine detail with a brush. When scraping, fine lines can be controlled with relative ease as long as the scraping is done on a dry surface.

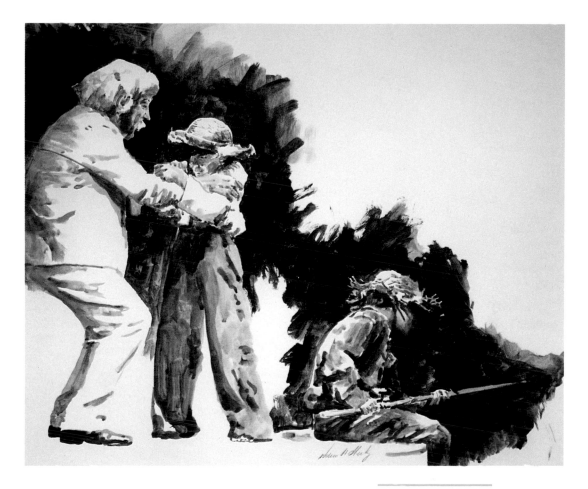

Mark Twain 20″ × 26″ (51 × 66 cm)
Utrecht 140 lb. Hot Pressed

The Utrecht 140 lb. Hot Pressed surface is far more attractive than its Cold Pressed counterpart. The sizing, however, is the same. Controlling the paints on the Hot Pressed surface can be tricky, as the paints tend to move around in the sizing. But if a painting is done with quick and deliberate strokes without too much scrubbing, this surface can produce some positive images.

Waterford 140 lb. Cold Pressed

Fiber Content: 100% rag
Surface Texture: Cold pressed
Weight: 140 lb. (300 g/m²)
Color: White
Size: 22″ × 30″ (56 × 76 cm)
Price Range: $3.25 to $3.95
Absorbency: Slight
Reworkability: Good
Watermark: T H Saunders. Embossed in corner with Waterford Series
Sizing: Very hard

T. H. Saunders, the manufacturer of Waterford watercolor papers, claims that the Waterford Cold Pressed paper is sized internally and externally. As a result, reworking and altering the paints is relatively easy. The surface will take a lot of abuse without altering paint quality. Deep values are difficult to achieve, as this paper is not very absorbent, and the pigments may precipitate out if large amounts are applied.

Waterford Cold Pressed lends itself to broad controlled washes, as well as modeling. The capillary action is slight, and capillary ridges are almost impossible to create.

The peaks and valleys of the surface are more rounded than most Cold Pressed surfaces, and this makes the paper feel smoother than it is. Because of this, I find this surface excellent for rendering very fine lines.

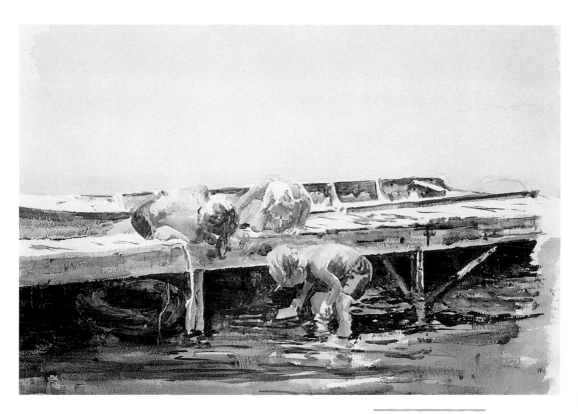

Anticipation 16″ × 21″ (41 × 53 cm)
Waterford 140 lb. Cold Pressed

I have used Waterford, formerly T. H. Saunders, for many years. The surface is one of the easiest to control in regard to broad even washes, smooth transitions of paint, and corrections. The paints sit high on the surface and can be manipulated without the paper coming apart.

In this relatively small painting I wanted to be able to render detail in some areas of the painting. The Waterford Cold Pressed surface lends itself well to detailed painting.

Waterford 140 lb. Hot Pressed

Fiber Content: 100% rag
Surface Texture: Hot
 pressed
Weight: 140 lb. (300 g/m²)
Color: White
Size: 22″ × 30″ (56 ×
 76 cm)
Price Range: $3.25 to
 $3.95
Absorbency: Slight
Reworkability: Good
Watermark: T H Saunders.
 Embossed in corner
 with Waterford Series
Sizing: Very hard

To my surprise I found the Waterford 140 lb. Hot Pressed surface very hard to control. Broad, even washes just were not possible, nor was it possible to control a graded wash. This surface seems more absorbent than other hot-and cold-pressed surfaces.

Colors do not seem as vivid as on some other hot-pressed surfaces, and dark values, although easy to obtain, dry with a muddy appearance.

The surface is very smooth, but it is difficult to create fine lines unless the brush is quite dry. Excess watercolors begin to spread in all directions making the marks appear rounded.

Creating highlights by scraping the surface can be accomplished, but the procedure has to be carried out with care. Heavy scraping may result in individual pieces of paper coming off the surface.

The Apprentice Magician 16″ × 20″ (41 × 51 cm)
Waterford 140 lb. Hot Pressed

This painting I consider a complete failure. As easy as the Waterford Cold surface is to control, the Hot Pressed surface is difficult. Generally, one particular line of paper will have similar qualities. Unfortunately, this is not the case with Waterford.

Waterford 140 lb. Rough

Fiber Content: 100% rag
Surface Texture: Rough
Weight: 140 lb. (300 g/m²)
Color: White
Size: 22″ × 30″ (56 × 76 cm)
Price Range: $3.25 to $3.95
Absorbency: Moderate
Reworkability: Fair
Watermark: T H Saunders. Embossed in corner with Waterford Series
Sizing: Very hard

The texture of this rough surface is moderate, but the texture does seem to have a definite direction. Utilizing the surface of the paper to create texture in a painting by dragging a dry-brush across the surface tends to leave marks across the paper, thus using this dry brush technique can be a frustrating experience. Broad controlled washes, however, are fairly easy on this surface. Modeling suits this paper as well.

Lifting dry paints on the rough surface can be difficult, but the surface can take a substantial amount of abuse, and, with some scrubbing, a substantial amount of pigments can be lifted. Scraping the surface to achieve highlights can be carried out with relative ease.

Colors on the rough surface dry quite true, and a wide range of values is also easy to obtain. Glazing techniques are easy on this surface.

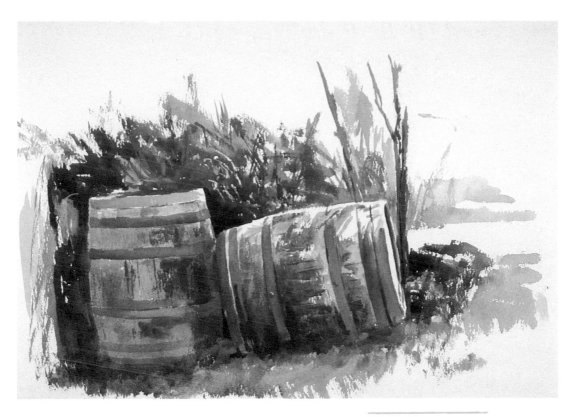

The Back Yard 14″ × 18″ (36 × 46 cm)
Waterford 140 lb. Rough

I often choose the Waterford Rough surface over the Cold Pressed whenever I need good control in the modeling of paints. And frequently the Rough surface lends itself to fine detail. This demonstration, which utilizes the texture of Waterford Rough and shows the ease of controlling the flow of paints, turned out to be a simple exercise.

Whatman 140 lb. Cold Pressed

Fiber Content: 100% rag
Surface Texture: Cold
 pressed
Weight: 140 lb. (300 g/m²)
Color: White
Size: 22″ × 30″ (56 × 76 cm).

Also available in blocks
Price Range: $2.75 to $3.50
Absorbency: High
Reworkability: Poor
Watermark: Whatman
Sizing: Weak

The Whatman name is an old one with regard to watercolor paper. The old Whatman papers, however, were discontinued in the fifties and a new paper under the Whatman name was introduced in the eighties. The old and new paper are quite different. The old paper was hard-sized, tough and durable, whereas the new Whatman Cold Pressed is absorbent and fragile in comparison.

Visually, the new Whatman paper is attractive and very white. The surface texture is almost void of any mechanical appearance, and the texture does not interfere with paint application.

Because of the absorbency of Whatman, broad, even washes are difficult. As with other absorbent papers, the paints are incorporated into the fibers quickly, making it impossible to manipulate the paints. Since the paints are absorbed into the fibers, lifting dry paints is also difficult. If the surface is scrubbed while wet, the paper fibers will loosen and come apart.

Being an absorbent paper, Whatman lends itself to drybrush painting. This technique renders vivid colors. When large washes are applied, however, the result can be disappointing, as the color seems to dry somewhat muted. When painting a subject, such as a figure, soft transitions can be achieved. The transitions, however, may be too soft. Achieving enough contrast is difficult when applying washes to achieve a soft effect. The paper is so absorbent that washes tend to even out the application of paints.

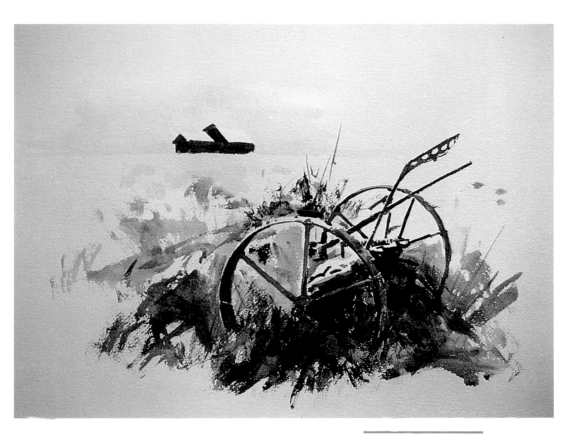

End of an Era 14″ × 20″ (36 × 51 cm)
Whatman 140 lb. Cold Pressed

Creating hard edges and modeling colors are difficult on this absorbent surface. Unless the paints are applied fairly dry or quickly the paper has a tendency to bleed and the colors run together. It is also a poor surface for such techniques as scrubbing and scraping.

Whatman 140 lb. Hot Pressed

Fiber Content: 100% rag
Surface Texture: Hot
 pressed
Weight: 140 lb. (300 g/m²)
Color: White
Size: 22″ × 30″ (56 ×
 76 cm). Also available in
 blocks
Price Range: $2.75 to
 $3.50
Absorbency: High
Reworkability: Poor
Watermark: Whatman
Sizing: Weak

The texture and the feel of this paper are very similar to print papers used for intaglio and lithography. And being an absorbent paper, it would serve well for printing processes.

As a watercolor support, however, it can be difficult to handle. Even, controlled washes over large areas may present some problems. When paints are applied, they will be absorbed into the paper, and unless a wash is very wet they will go on unevenly. The smooth surface does not hold the watercolors in suspension long enough to allow the paints to be manipulated to any great extent. If the paper is on an angle while being painted and additional moisture is added to insure manipulation, the excess paints tend to run.

Having little or no sizing, this paper is not a good support for abusive techniques. Scrubbing with a hard brush will make the paper fibers come apart. Scraping the surface, either wet or dry, will remove rather large pieces of the surface.

But this paper can be used very successfully for drybrush techniques. In addition, very fine details can be obtained on this surface, as long as the brush is kept fairly dry.

Canadian Mist 14″ × 20″ (36 × 51 cm)
Whatman 140 lb. Hot Pressed

I was unable to obtain a dramatic sky in this painting as the surface will not hold enough watercolor to allow additions of various values of paint without running. The surface, however, is well suited for drybrush.

Whatman 140 lb. Rough

Fiber Content: 100% rag
Surface Texture: Rough
Weight: 140 lb. (300 g/m²)
Color: White
Size: 22″ × 30″ (56 × 76 cm). Also available in blocks
Price Range: $2.75 to $3.50
Absorbency: High
Reworkability: Poor
Watermark: Whatman
Sizing: Weak

Since this paper is very absorbent, dark values are simple to obtain. Because the Rough is so absorbent, painting around an object should be done with little moisture in the brush in order for the pigments not to travel.

Abusive techniques such as scrubbing and scraping are difficult on any Whatman watercolor paper. When scrubbing, the surface will come apart easily, and if the surface is subjected to scraping it tends to come off in large pieces. Corrections by lifting already dry paints are not easy. Since the pigments are absorbed into the fibers they are hard to remove.

Even, controlled washes can be done with little effort. The paints will blend with each other without creating capillary ridges. The only problem comes in trying to go from a very light value of color to a dark one or the reverse. The paints blend on a wet surface and will travel a long distance. If a graded wash is desired, it is necessary to wait until the initial wash is semidry before applying additional pigments. Otherwise, the wet areas of your painting will end up having the same value.

Before the Hunt 14″ × 20″ (36 × 51 cm)
Whatman 140 lb. Rough

*This paper suited the subject, as it required dark values in the background.
The absorbency of the Whatman Rough surface worked well for this without
my having to apply many glazes.*

HANDMADE PAPERS

It wasn't long ago when the answer to the question, "Is handmade paper really worth the price?" would have been a determined "no." More recently the answer has changed.

There is nothing more alluring and attractive than a well-crafted sheet of handmade paper, and, to many, it is a work of art. If the paper is considered a work of art, the price becomes secondary. The selection of handmade paper readily available on the market is very limited, but it is possible to find discontinued sheets in print shops and large art supply houses.

Handmade paper can be either wove or laid, but most Western watercolor papers are wove with surface textures classified as cold pressed or rough. An uncut handmade sheet has four deckles that are irregular, and the perimeter usually has a wave-like pattern not found in paper made by machine. This pattern is practically impossible to remove regardless of what is done to the sheet. I have one sheet of discontinued Whatman paper watermarked 1950. That sheet, even though it has been stored under pressure, still has the characteristic waves along the edges. Deckles are easily made by machine. The individual sheets are cut with jets of water just after the paper pulp is laid on the continuous mold, before the sheets are pressed. At first glance these papers resemble handmade sheets, but each sheet is exactly alike and the deckles are straight without irregularities.

Another sign of handmade paper is the distribution of pulp throughout the sheet. Irregularities that appear in the form of lumps, both on the surface and within the sheet, can indicate a handmade sheet. Holding the paper in front of a light will usually reveal uneven spots of pulp concentration. The irregularities do not interfere with the performance of the paper.

Handmade paper tends to buckle more than machine-made paper, because handmade paper is pressed between blankets after it comes off the mold rather than pressed through rollers. This leaves the fibers less compact and permits greater water absorption, which in turn makes the paper expand more. This can be annoying, especially if a watercolor painting is carried out on a flat horizontal surface, since the buckling will create valleys where paint collects.

To reduce buckling some painters will choose a heavyweight paper or resort to stretching, but in using handmade paper a few problems may arise. The selection of handmade paper is very limited, and a paper heavy enough to reduce buckling is extremely costly. Quite often the personality of the painter will change when confronted with a blank sheet of paper costing in the neighborhood of $14.00 per sheet. Suddenly, the paper is handled as if it is spun gold, and the last thing on the painter's mind is painting. Once the initial fear is overcome and the business of painting is at hand, a decision to paint a masterpiece in order to justify the price of paper is a common reaction. The result, more often than not, is a tight and overworked painting.

Stretching is an old technique used to flatten watercolor paper, but in the case of handmade paper the most attractive and also valuable parts of the paper will be lost. Since the perimeter is taped down, the deckles would be lost, and in the case of old paper precious watermarks could also be eliminated. I have some old prints where the watermarks are in the middle of the paper, but this is a rarity in watercolor paper.

Stretching a handmade paper can produce undesirable results. Because of the irregularities in pulp distribution, the paper may not shrink evenly, resulting in raised areas that may transverse the entire sheet. If this happens, not only is the perimeter lost, but in some cases you will lose the rest of the sheet as well because the raised areas cannot be removed. Dry mounting will eliminate buckling in most machine-made watercolor paper, but in handmade paper the undulating perimeter may not flatten, sometimes creases result, and, as with the wave pattern, once the creases are in the paper they cannot be removed.

Comparing painting qualities of handmade paper to that made by machine, I would choose machine-made for most of my work. Besides being available at a much lower cost, the selection of machine-made paper is substantially greater and allows the painter a far greater choice of surface texture, weight, sizing, and wet strength.

One very positive aspect of a well-crafted handmade paper is a true wove surface. Most machine-made papers will have some bias in grain direction or texture, whereas the handmade sheet is void of any interference by mechanical processes.

Fabriano Esportazione

Fiber Content: 100% rag
Surface Texture: Cold
 pressed
Weight: 147 lb. (315 g/m²)
Color: White
Size: 22″ × 30″ (56 ×
 76 cm)
Price Range: $6.85 to
 $14.00
Absorbency: Moderate
Reworkability: Fair
Watermark: Fabriano-
 Handmade (Italy)
Sizing: Hard

Street Fair 20″ × 28″ (51 × 71 cm)
Fabriano Esportazione 147 lb. Cold Pressed

If you've never had the pleasure of painting on a well-crafted handmade paper perhaps Esportazione would be a good choice.

My initial positive reaction to this paper was not based on its appearance but rather on how it felt. In comparison to other watercolor papers of equal weight, Esportazione feels a little thinner to the touch. The true wove surface is, however, to say the least, exquisite to touch. The sizing is hard, which can be heard by the high pitch created if the paper is shaken back and forth. Absorbency is moderate, leaving the paints on the surface and giving you ample time for modeling and corrections.

Esportazione buckles to such an extent that painting without first stretching the sheet is practically impossible. When stretched, the paper presents a perfectly flat surface. I was pleasantly surprised as soon as I had started painting on the stretched surface. The paints went on without any interference from grain direction or abrasion.

Absorbency had not changed from stretching the paper, as is the case with many watercolor papers, and the paints sat long enough on the surface to be manipulated without creating capillary ridges. Wet strength is good, but excessive scrubbing will loosen the paper fiber—but not to the extent of Esportazione's machine-made counterpart Artistico. Watercolors are brilliant on Esportazione, and glazing techniques are particularly well suited to this surface, as the underlying paints, once dry, are difficult to lift.

Of all the watercolor papers I have tried, Esportazione is without a doubt one of the finest and also the easiest to control. Its superb color saturation, along with a true wove surface, makes this paper a joy to work on.

The two major drawbacks with Esportazione are, of course, cost and the necessity to stretch the paper. But if you have no objections to cost or stretching, I would highly recommend trying Esportazione.

Indian Village

Fiber Content: 100% rag
Surface Texture: Rough
Weight: 140 lb. (300 g/m²)
Color: Light gray
Size: 22″ × 30″ (56 ×
 76 cm)
Price Range: $1.80
Absorbency: High
Reworkability: Poor
Watermark: None
Sizing: Weak

Painting on Indian Village can only be described as a battle between painter and paper. The score was 0 for 3 before I gained some control over Indian Village.

Indian Village comes in one surface texture, Rough, and it is one of the roughest surfaces I have encountered both in sight and touch. The distributor's description includes the term "crude sheet," which indeed it is. Pulp concentration is quite irregular, and on some sheets I have seen lumps of paper pulp on the surface. The Rough surface is so rough that it interferes with paint control, but for the painter who wishes to accent texture or simply to use the texture as an experimental tool, Indian Village is the right paper to use.

According to the distributor's claim, sizing is internal. I doubt, however, that this is the case. If Indian Village is soaked briefly and stretched, much of the sizing is lost, and the paper becomes quite absorbent, which leads me to believe that the sizing is external.

Wet strength is poor and scrubbing will loosen the paper fibers rapidly. When the paper is in the process of being stretched, air bubbles form under the paper, and pushing the air bubbles out by hand has to be done very carefully because of the paper's poor wet strength. If Indian Village is handled with the slightest amount of abuse while wet, the fiber will separate from the surface. Scraping the surface while it is wet results in large areas of paper being removed. Sanding should not be tried on this surface unless the painter has some specific effect in mind.

Corrections on Indian Village are very difficult. Once dry, watercolor pigments are well into the paper fibers, and the technique of rewetting an area to be corrected and lifting the pigments with a dry brush or sponge does not work on this surface. The only way to remove pigments from this surface is to remove the paper fibers. This can be accomplished by scrubbing the wet surface until the paper fibers are loose, then after the painting is completely dry the fibers can be brushed off with a brush or towel.

One surprising feature of Indian Village is that even though the paper itself is gray, the areas not painted appear white in the completed painting.

Indian Village is definitely a unique paper, and, considering the modest cost, it is well worth a try, if for nothing else than experimenting on a truly different surface that could open new horizons for the experimental painter.

The Round Tower
26″ × 18″
(66 × 46 cm)
Indian Village
140 lb. Rough

Note the light coming through the window in this illustration. The gray tone of the paper does not interfere at all. This illustration is also an example of transparent drybrush on unstretched paper. By utilizing this technique, buckling was kept to a minimum.

Twinrocker Feather Deckle

Fiber Content: 100% rag
Surface Texture: Cold
 pressed
Weight: 200 lb. (400 g/m²)
Color: White
Size: 10″ × 14″ (26 ×
 36 cm), 16″ × 21″ (41 ×
 53 cm). Also available in
 12″ and 18″ diameter
 circles
Price Range: $5.45 per
 10″ × 14″ sheet, $7.85
 per 18″ diameter circle
Absorbency: Moderate
Reworkability: Poor
Watermark: None
Sizing: Medium

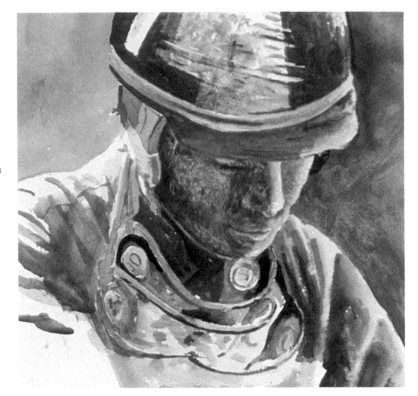

My first reaction to this particular paper was its overall appearance. The brilliant white surface and the four exaggerated deckles carry an immediate visual impact. A close inspection of the surface reveals a totally unbiased texture void of any grain direction or mechanical manufacturing techniques. The surface is soft to the touch and quite smooth for a paper rated as cold pressed, but it does have a distinct random texture. It is one of the most attractive papers I have seen.

Before I even began to paint on Twinrocker I encountered difficulties. My immediate problem was to pick a subject matter that would utilize the exaggerated deckles and at the same time make the painting, rather than the paper, stand out. A second problem, purely personal, was the cost of the paper. To paint on a small surface, at a cost of nearly $8.00, tends to make me a bit cautious.

My first attempt was a failure. I painted some white flowers on a dark background, but the background appeared somewhat muddy. When I tried to lift some of the excess pigments I found that it wasn't possible on this surface. Scraping Twinrocker is difficult, as the paper is soft, resulting in bits of paper coming off the surface. The resulting irregular surface will absorb additional watercolors into the paper fibers.

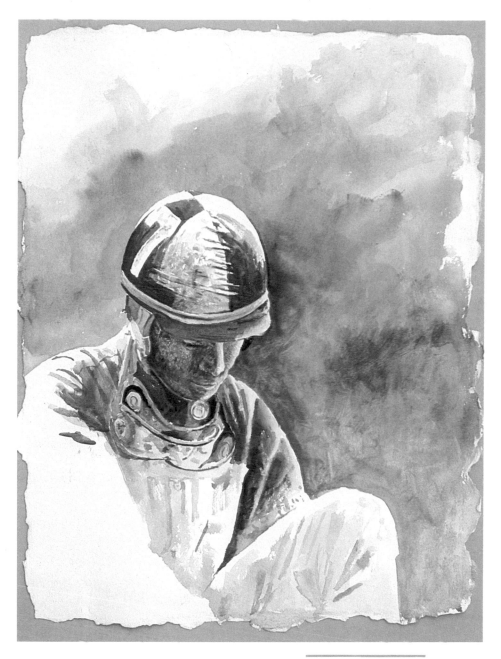

After the Race 19″ × 14″ (48 × 36 cm)
Twinrocker Feather Deckle 400 lb. Cold Pressed

*This illustration is the result of my using fewer washes and more drybrush.
Initially, I wanted an even wash for the entire background, but, because the
paper is very absorbent, the background had to be painted with glazes in or-
der to control values of paint.*

WATERCOLOR BOARDS

An alternative to stretching paper is the watercolor board. These boards are made by laminating a sheet of watercolor paper to a heavy piece of cardboard that, because of its thickness, resists the buckling of the paper while painting. Although the watercolor board will not buckle, it will warp if the entire surface is saturated with water and allowed to dry.

Among the boards I have tried, the painting qualities are quite similar. The boards seem to be less absorbent than individual sheets of paper, which may be a result of the process of lamination. All the surfaces feel quite hard and the textures are smoother than individual sheets graded exactly the same.

Techniques such as scraping and sanding can be carried out with better control on boards, as the paper itself is held firmly in place on the supporting cardboard. Such paper as the cold-pressed Fabriano, however, remains quite soft even after it has been laminated. To my knowledge, Fabriano does not manufacture watercolor boards, but I have laminated some cold-pressed Artistico sheets by Fabriano, and such techniques as scrubbing and scraping are not suited to this surface.

Crescent Watercolor Board

Fiber Content: 100% rag
Surface Texture: Hot
pressed, cold pressed,
rough
Weight: Not applicable
Color: White
Size: 20" × 30" (51 ×
76 cm), 30" × 40" (76 ×
102 cm)
Price Range: $5.00 to
$8.00 per 20" × 30"
board, $10.00 to $16.00
per 30" × 40" board
Absorbency: Slight
Reworkability: Fair
Watermark: None
Sizing: Hard

Going Home 14" × 18" (36 × 46 cm)
Crescent Watercolor Board

Working on a laminated watercolor surface makes a painting like this illustration almost a simple exercise. The flat surface, coupled with the board's slight absorbency, makes large washes easy to control. In addition, glazing techniques and the control of paint values are also a plus on this surface.

Little information is provided regarding this laminated watercolor paper. One catalog simply states that the paper is rag, but beyond that no other information is given. The back of the board states that the board is laminated with a Strathmore 100 percent rag watercolor paper.

Judging from the appearance of the surface, this laminated paper looks like Strathmore Imperial or Gemini, but, being a laminated paper, the absorbency is reduced.

One very positive feature with regard to Crescent watercolor board is that it is available in a large size. Painting large watercolor paintings on sheets of paper not mounted or stretched is difficult, to say the least. Sheets of unmounted paper generally buckle severely when washes are applied to large areas. On a mounted paper there is no interference from an irregular painting surface.

Although this surface can take more abuse than unmounted Gemini or Imperial, excessive scrubbing will loosen the paper fibers. Scraping the surface when wet should be done with care, as much of the paper's strength is lost when the surface is saturated. The technique of sanding the surface to lighten values is a difficult one on this support, even though the paper is mounted.

Glazing on this surface is relatively easy, as the underlying paints are not lifted with ease. In addition, colors are vivid and the surface texture seems to have less of a direction than individual sheets of either Imperial or Gemini.

Arches Watercolor Board

Fiber Content: 100% rag
Surface Texture: Hot pressed, cold pressed, rough
Weight: Not applicable
Color: White
Size: 22″ × 30″ (56 × 76 cm)
Price Range: $6.50 to $10.85
Absorbency: Slight
Reworkability: Good
Watermark: None
Sizing: Hard

Rascal 12″ × 16″ (30 × 41 cm)
Arches Watercolor Board

The hard sizing on Arches watercolor papers makes the watercolor boards seem even less absorbent than individual sheets. Colors have a tendency to run if the surface is on a high angle while being painted.

The surface of Arches watercolor board is graded in the traditional manner. Each of the graded surfaces, however, feel and look smoother than individual sheets graded the same.

Another feature that seems less pronounced is the board's absorption rate. The watercolors sit high on the surface, and if the board is on an angle when painting, the colors tend to run more quickly than on individual sheets. As the surface is not very absorbent, manipulation of the paints is relatively easy, especially on the rough surface. The rough surface provides ample texture to retain watercolors in suspension, allowing time to manipulate the paints.

This hard surface will remain flat during the process of painting. Because watercolor boards remain flat, they are well suited for abusive techniques. It is far easier to control the scraping of the surface of a mounted or stretched paper than a loose sheet. Since loose sheets tend to buckle a little, the process of scraping is not as easy to control as on a mounted surface.

One technique that is simpler to control on a mounted surface is sanding. A thin layer of paint or ink can be removed to lighten the values, however, and the sanded surface will become more absorbent. Reworking the sanded area results in the paints entering the paper fibers and the sanded area becoming darker than the parts of the paper that have not been sanded.

Whatman Watercolor Board

Fiber Content: 100% rag
Surface Texture: Cold pressed
Weight: Not applicable
Color: White
Size: 20″ × 30″ (51 × 76 cm), 30″ × 40″ (76 × 102 cm)
Price Range: $7.70 to $9.00 per 20″ × 30″ board, $15.40 to $18.00 per 30″ × 40″ board
Absorbency: Moderate
Reworkability: Poor
Watermark: None
Sizing: Hard

Improvisation 20″ × 14″ (51 × 36 cm)
Whatman Watercolor Board

This cold-pressed surface has less texture than individual sheets graded the same because of the lamination process. The combination of reduced texture and absorption provides the painter with a surface well suited for glazing, as well as graded washes. Deep values are also a plus on this surface, as the colors keep their value when the painting has dried.

Abusive techniques are not recommended on this surface. Although the surface may feel quite a bit harder than an individual sheet, the paper is the same. And like all Whatman papers, the fibers tend to come apart with excessive manipulation.

The cost of these boards may be somewhat high for many painters but painting on a surface like the Whatman watercolor board can only be called a pleasure.

BRISTOL BOARDS

One of the popular alternatives to traditional watercolor paper is Bristol Board, especially among experienced painters. Colors tend to be vivid, sitting on top of the paper surface, and attractive "accidents" are a frequent plus. Although accidents happen frequently it does not mean that Bristol Board cannot be controlled. With a little patience and manipulation, some rather stunning paintings can result.

Unlike watercolor paper, the surface texture of Bristol Board is described as plate or vellum. There is very little difference between the plate and vellum surface textures. The plate surface is usually void of any texture, whereas the vellum has a slight tooth, and both surfaces are excellent recipients for pencil and pen drawings.

The weight of Bristol Board is measured in ply, or the number of sheets laminated together. A one-ply Bristol Board is very thin and difficult to control with water-based paints, as Bristol Board has a tendency to buckle rather severely. A Bristol Board thicker than three-ply, however, is a good recipient for watercolor paints. Six- to eight-ply board is expensive and quite heavy.

Bristol Boards are not designed for watercolor painting, and one of the major drawbacks is the tendency for the boards to buckle. Some boards buckle to such an extent that controlling a full size 22″ × 30″ (56 × 76 cm) sheet is virtually impossible. Most paintings I have seen rarely exceed 15″ × 22″ (38 × 56 cm) and most are no larger than 8″ × 10″ (20 × 26 cm).

The surface of both plate and vellum is quite hard and is well suited for pen and ink, pencil, and other drawing media requiring some pressure. The plate surface is very smooth, and it is often possible to be able to lift most watercolor paints even after they have dried, which in turn opens endless variations of painting techniques. The smooth surface also lends itself well to small paintings, as the surface texture does not compete with the image, as is often the case with small paintings on a rough-textured paper.

The vellum surface has a slight tooth, and it is also more absorbent than its plate counterpart, but it is not as textured as a cold-pressed watercolor paper. Corrections are not as easy on the vellum surface as on the plate. At times the watercolor paints tend to get into the top layer of fibers and are then difficult to remove.

Such corrections as scrubbing and scraping can be done on a limited basis. Scrubbing the surface with a bristle brush will loosen the fibers in some of the boards if more than light pressure is applied. Scraping the surface for highlights is sometimes difficult, as the surface may not come off in a linear fashion; instead, there is a tendency for the surface to come off in small, irregular chunks of paper.

The only major disadvantage to using Bristol Board for watercolor painting is its tendency to buckle. When washes are used covering the entire board, many of these Bristol Boards will curl up into a roll during the drying process, and there is a definite need to fasten down the perimeter. Both surfaces are good recipients for drybrush painting, especially the vellum, and very detailed works can be painted on either.

Canson Bristol Board

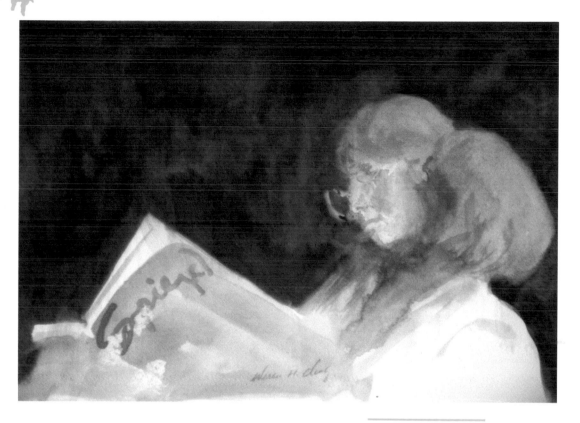

Spiegel Catalog 5″ × 7″ (13 × 18 cm)
Canson Bristol Board

Fiber Content: 100% rag
Surface Texture: Plate
Weight: Not applicable
Color: White to off-white
Size: 22″ × 30″ (56 × 76 cm).
 Also available in pads

Price Range: $1.40 to $3.00
Absorbency: Slight
Reworkability: Good
Watermark: None
Sizing: Hard

Although this painting is small, the board buckled severely. The only way to gain some control of this buckling was to wet the reverse side of the paper, which flattened the board.

Strathmore 300 Bristol Board

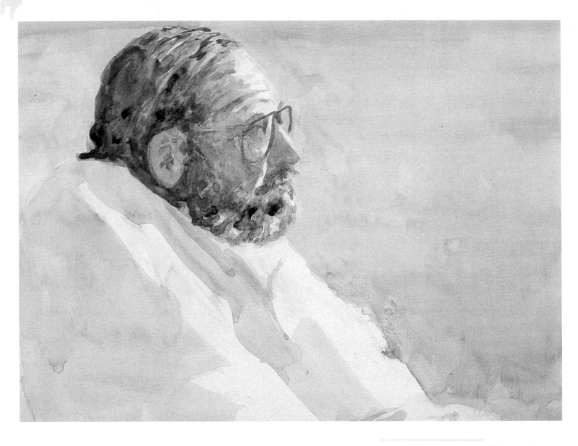

Dr. Jointner 9″ × 12″ (23 × 30 cm)
Strathmore 300 Bristol Board

Fiber Content: 100% rag
Surface Texture: Vellum
Weight: Not applicable
Color: White to off-white
Size: 22″ × 30″ (56 × 76 cm).
 Also available in pads

Price Range: $1.40 to $3.00
Absorbency: Slight
Reworkability: Fair
Watermark: None
Sizing: Hard

*This surface buckles far less than most other Bristol Boards. The absorbency
is also slightly higher, making it easier to control the values.*

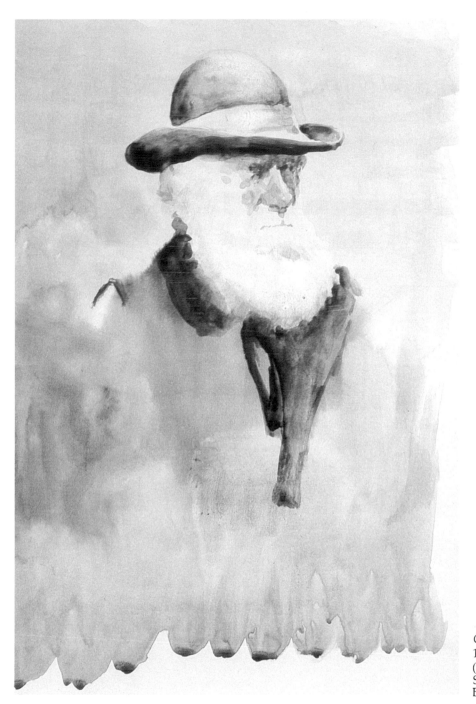

Charles Darwin
14″ × 10″
(36 × 25 cm)
Strathmore 300
Bristol Board

I find the strong capillary ridges on this board particularly well suited for portraiture. These uncontrollable events often add positive paint qualities that are hard to obtain on traditional watercolor paper.

ILLUSTRATION BOARDS

Although not made specifically for watercolor painting, illustration boards can be an excellent support. Because it is in the form of a board, the surface remains flat when used for watercolor painting. Some of the boards, however, will warp in the process of drying if the entire surface has been saturated with water. If this warping is excessive, the board can be flattened by giving the back of the board a coat of water.

The surface can be either cold or hot pressed. The cold-pressed surface is usually smoother than a cold-pressed watercolor paper, and the hot-pressed surface resembles that of a plate surface found on Bristol Boards.

Using watercolor on these supports may be somewhat tricky for the beginner. The surface is quite hard and not very absorbent. If painting is done on an angle, the flow of paints, running downward, is faster than on most watercolor papers. For transparent watercolors, less paint has to be loaded on the brush in order to control the flow.

When painting on a hot-pressed board, the paints are very hard to control. Paints tend to stay on top of the board and, when dry, will redissolve easily. This effect makes dark values difficult to obtain. Subsequent glazes on hot-pressed boards will not go on top of one another; they simply mix with the underlying paints.

Such techniques as scrubbing and scraping are easy on most illustration boards, as the surface does not come apart easily. Sanding the surface to lighten values is another method that can be controlled with relative ease.

Illustration boards are excellent supports for pencil and pen drawings, and, in combination with watercolor, stunning effects can result.

During periods of high humidity I find illustration boards a better recipient of watercolor than papers made specifically for watercolor. Feathering and bleeding seem less pronounced on illustration boards when humidity is very high. Detailed painting on some watercolor papers is sometimes not possible during periods of high humidity; when that happens I often switch to illustration board.

Strathmore 500 Illustration Board

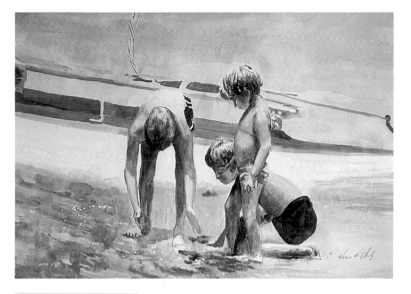

Fiber Content: 100% rag
Surface Texture: Regular or smooth
Weight: Light- or heavyweight
Color: White
Size: 22″ × 30″ (56 × 76 cm) lightweight, 20″ × 30″ (51 × 76 cm) and 30″ × 40″ (76 × 102 cm) heavyweight
Price Range: $4.50 to $5.50 lightweight. $5.50 to $7.00 and $11.00 to $14.00 heavyweight
Absorbency: Slight
Reworkability: Good
Watermark: None
Sizing: Hard

Coming Home 16″ × 26″ (41 × 66 cm)
Strathmore 500 Illustration Board

This is an example of the hot-pressed illustration board surface. The paints proved extremely difficult to control for this illustration, because the surface tends not to absorb the watercolors.

Like other illustration boards, the Strathmore board is not designed for watercolor. The board is made by laminating a 500 series drawing paper on both sides of a heavy cardboard. The regular surface, although quite smooth, shows some direction of texture. This directional texture does not interfere with watercolor painting. As the regular surface is quite smooth and not very absorbent, watercolors can be hard to control. Watercolors will flow very quickly on this surface, as they remain on top. This in turn also makes it difficult to obtain deep values without the colors going sour or dull.

The smooth surface is practically void of any texture and resembles a plate finish on a bristol board. Controlling the flow of paints on the Strathmore 500 illustration board is thus practically impossible, but this phenomenon gives watercolor paintings a rather unique look.

Strathmore is a laminated support and thus can take more abuse than individual sheets. Scrubbing and scraping can be employed without the surface falling apart. Sanding the surface to lighten values, or as a corrective measure, is a useful technique on illustration board. Since the board is very hard and the surface fairly smooth, it is possible to control the amount of paper to be removed by sanding. Even though the surface texture is changed by sanding, the resulting surface can be reworked with paint or ink. On the smooth surface, paints can be wiped off without scrubbing. Scraping the smooth surface can be controlled to such an extent that the scraped area looks like scratchboard.

Crescent Hot Pressed Illustration Board

Fiber Content: 100% rag
Surface Texture: Hot pressed
Weight: Single- or doubleweight
Color: White
Size: 20″ × 30″ (51 × 76 cm), 30″ × 40″ (76 × 102 cm)
Price Range: $2.25 to $3.00 for 20″ × 30″ singleweight, $3.00 to $4.00 for 20″ × 30″ doubleweight, $6.00 to $8.00 for 30″ × 40″ doubleweight
Absorbency: Slight
Reworkability: Good
Watermark: None
Sizing: Hard

Southern Comfort 14″ × 18″ (36 × 46 cm)
Crescent Hot Pressed
Illustration Board

There is little variation of texture on the Hot Pressed illustration board surface. The surface is very smooth, and watercolor paints are thus very difficult to control.

Since the watercolors are almost impossible to control, some rather unique "accidents" take place. The paints tend to flow quickly if the painting is on an angle when painted. If the surface is kept flat, the paints tend to go in every direction.

Corrections on the Hot Pressed surface are simple tasks. Dry paints can be lifted by rewetting an area and scrubbing with a drybrush or tissue. The technique of scraping is also easy. As the paints sit on the surface, there is no need to scrape into the board itself. It is usually possible to remove the paints themselves by scraping without removing any of the surface itself.

Glazing is not possible, as the underlying paints will dissolve when the glaze is applied, resulting in a mix rather than a glaze. Drybrush

techniques are possible if the brush is very dry.

Although illustration boards don't buckle, they do have the tendency to warp. Singleweight (a measure of thickness) boards will warp excessively if the entire surface has been saturated with water. In the process of drying, the board will take the shape of a half circle. This can be avoided if the back of the board is made as wet as the front.

The hot-pressed surface supporting this illustration made it difficult to obtain dark values. Glazes tend to simply mix with the paints.

PRINT PAPERS

Papers produced for printing, whether for fine art or for commercial printing, comprise the largest section of the printing industry. Although not made specifically for watercolor painting, some of these medium are well suited for this.

Both laid and wove surfaces are available, as well as surfaces resembling hot- and cold-pressed watercolor paper; however, very rough surfaces are seldom made for printing.

Print papers are generally very absorbent, as they contain little or no sizing, and manipulation of watercolor paint is limited. Most print papers are not suited for such techniques as scrubbing or scraping, as they are quite soft, because of the lack of sizing.

One feature found in print paper that is absent in watercolor paper is color. A wide variety of colors are available, and some of these papers can be used successfully with a combination of transparent and opaque paints.

BFK Rives

Fiber Content: 100% rag
Surface Texture: Smooth
Weight: 130 lb. (280 g/m²)
Color: White, cream, gray, and tan
Size: 22″ × 30″ (56 × 76 cm), 44″ × 60″ (112 × 152 cm). Also available in rolls
Price Range: $1.75 to $2.25 per 22″ × 30″ sheet
Absorbency: High
Reworkability: Poor
Watermark: BFK Rives France
Sizing: Very weak

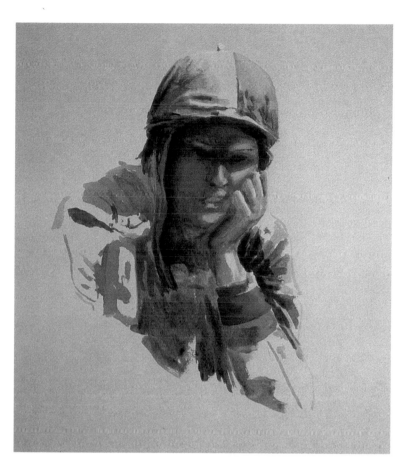

The Jockey 14″ × 20″
(36 × 51 cm)
BFK Rives

Realistic figures, such as the one in this illustration, can be produced quite effectively on the tan BFK Rives paper. And this brand rarely shows signs of fading.

BFK Rives can be an excellent surface for water mediums even though it is not classified as a watercolor paper. As with other print papers, BFK Rives is quite soft and absorbent and will not take the same amount of abuse as a good watercolor paper, especially when soaked with water. Scrubbing and scraping while the surface is wet have a tendency to separate the surface fibers. Painting on the damaged surface is difficult.

The gray and tan BFK Rives are tinted with pigments rather than dyes and are therefore resistant to fading. In the twenty years I have been using this paper, none have shown any signs of the fading I have seen in many other colored papers.

The tan BFK is an excellent ground for rendering realistic figures. Oil-painting techniques can be used on the toned ground to achieve a realism in watercolor painting rivaling even that of oil.

Rendering is equally effective on the gray BFK paper. I use this paper for architectural renderings and city landscapes. To achieve a unique effect that is hard to accomplish on other surfaces, combine pencil, or pen and ink, with transparent washes and opaque highlights.

Arches Cover

Fiber Content: 100% rag
Surface Texture: Not rated
Weight: 117 lb. (250 g/m²)
Color: White, buff
Size: 14″ × 18″ (36 × 46 cm), 22″ × 30″ (56 × 76 cm)
Price Range: $1.75 to $2.25 per 22″ × 30″ sheet
Absorbency: High
Reworkability: Poor
Watermark: Arches France
Sizing: Weak

Secession 14″ × 18″
(36 × 46 cm)
Arches Cover

Arches Cover is classified as a print paper, and like most print papers it contains little sizing. This paper is not quite a waterleaf, but it is very absorbent. The surface can be difficult for the novice artist, as pigments are absorbed into the paper fibers quite readily. Corrections on Arches Cover can be very difficult, even while the painting is wet. Although the paper is durable, it will not take much abuse when wet. Scraping or sanding is not advisable because the paper fibers will separate. This form of correction is not easy to control on Arches Cover.

This support can be very effective when painting wet on wet. The paper does not have a grain direction, and, consequently, the capillary action distributes the moisture evenly. The paper's affinity for moisture insures ample painting time on a wet ground.

This illustration was a wet-on-wet painting. The lack of a grain direction makes this paper ideal for this technique.

Stonehenge Rising Paper

Fiber Content: 100% rag
Surface Texture: Not rated
Weight: 150 lb. (320 g/m²)
Color: White, cream,
 natural, gray, tan
Size: 16″ × 22″ (41 ×
 56 cm), 22″ × 30″ (56 ×
 76 cm), 30″ × 44″ (76 ×
 112 cm)
Price Range: $1.05 to $1.50
Absorbency: High
Reworkability: Poor
Watermark: None
Sizing: Medium

Clyde Beatty 16″ × 22″
(41 × 56 cm)
Stonehenge Rising Paper

This paper is manufactured primarily for printmaking, but it can be used successfully as a watercolor support. It is sized heavily in comparison to most other print papers. Controlling an even watercolor wash can be difficult. The paper is sized internally, allowing pigments to soak into the paper fibers. Lifting and otherwise altering the paints are difficult once the painting is dry.

Watercolor paints on internally sized papers can appear dull in comparison to papers that are sized externally. Stonehenge is no exception. The overall appearance of a dry painting on this surface is not as vivid as paintings executed on pa-

pers made especially for watercolor painting. Despite this, the paper should be considered by the watercolor painter because of its moderate cost, extensive color line, and variety of use; that is, pencil or pen and ink, as well as watercolor painting.

This versatile paper does not give a particularly vivid look to finished, dry works, but it is inexpensive and comes in many colors.

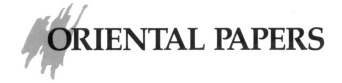ORIENTAL PAPERS

Papers for painting and calligraphy manufactured in China and Japan are often referred to as *rice paper*. These papers, however, are made from just about anything but rice.

In contrast to Western watercolor paper, oriental paper for watercolor is very fragile when wet. Lifting a moderate-size oriental paper when wet just isn't possible. When the paper is picked up by hand, it will fall apart as soon as there is the least amount of resistance. Any form of abuse to wet oriental paper will result in the paper fibers coming apart.

Generally, these papers have little or no sizing; consequently, they are very absorbent. The absorbency plus the fragile nature of these papers dictates the painting process. Corrections are not possible. As soon as the watercolors touch the surface, they are absorbed into the paper and cannot be lifted. Any form of manipulating the paints only results in the paper coming apart, even if done with a gentle hand. Controlling the amount of paint in the brush is also necessary, as any excess will spread without any hope of controlling the feathering.

Those who paint on this paper all work on a flat horizontal surface. Many will place an absorbent paper under the paper to be painted. This is to give some control in reducing feathering of excess paint. The brush is generally held perpendicular to the paper, but at times the brush is tilted to achieve different effects. Loading the brush with the right amount of paint is also important. To obtain details on oriental paper it is necessary to remove any excess paint from the brush. This can be done by either squeezing the brush by hand or wiping the excess paint on another paper. It takes some practice getting to the point where the painter can control the amount of paint in the brush consistently.

It is a common practice to mount oriental paper prior to painting or after a painting is finished. The supports used for mounting can be muslin, linen, canvas, or such board as masonite. Glues used for the mounting process should be water soluble. The two main glues are wheat paste or fish glue.

The mounting process itself is a difficult one. The support for the paper is covered with glue; then, with the help of another person, the paper is allowed to sag in the middle. When the middle of the paper touches the wet glue it immediately soaks up moisture and expands. The expansion results in wrinkles and air pockets under the paper. Removing the wrinkles and air pockets is done with a large soft brush, usually a hake brush. As the paper is lowered onto the glue surface the wrinkles and air pockets are brushed; always brush from the middle out.

Another method of mounting is to roll-out the paper. Again, the support is covered with glue, and, holding the roll of paper in one hand, the end is lowered onto the glued surface. As the paper touches the support the wrinkle and air pockets formed are brushed out.

Painting on a mounted oriental paper is a little easier than painting on one that is not. Feathering is reduced, and the paper is far less prone to come apart.

Oriental Paper Mounted on Masonite

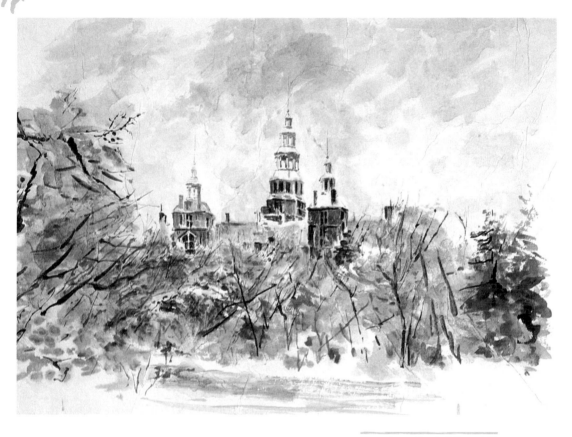

Rosenborg Castle 24″ × 30″
Oriental Paper Mounted on Masonite

Fiber Content: Various
Surface Texture: Not
 classified
Weight: Not applicable
Color: White, off-white
Size: 24″ × 30″ (61 × 76 cm)

Price Range: $2.80 to
 $3.60
Absorbency: Very good
Reworkability: Poor
Watermark: None
Sizing: Very weak

Mounting this fairly large sheet resulted in numerous wrinkles that were impossible to remove. Since the painting was to be a landscape, I ignored the wrinkles and incorporated them into the painting.

Oriental Paper Mounted on Canvas

Fiber Content: 100% rag
Surface Texture:
 Unclassified
Weight: 140 lb. (300 g/m²)
Color: White
Size: 16″ × 12″ (41 ×
 30 cm)
Price Range: $2.80 to
 $3.60
Absorbency: Very good
Reworkability: Poor
Watermark: None
Sizing: Very weak

Detail of Procession

Capillary ridges are far more pronounced on mounted oriental paper. This is the result of the glue used for mounting. Although the paint surface is still very absorbent, feathering is retarded by mounting the paper, which, in turn, results in capillary ridges.

Procession 16″ × 12″
(41 × 31 cm)
Oriental Paper
Mounted on Canvas

The paper used in this illustration was obtained by a friend directly from China. It is a laid paper with a smooth surface. Particular brands from China and Japan are available at most art supply stores.

ORIENTAL PAPERS

OTHER WATERCOLOR SUPPORTS

Papers made specifically for watercolor painting may be one of the smallest segments of the paper industry. There are, however, many other supports, such as Bristol Boards and illustration boards, as well as print and drawing papers, that are well suited for the watercolor media.

Solid supports, like illustration boards, are a favorite of many artists. The surfaces are generally smoother than watercolor papers with the same rating, and they are less absorbent. The surface, consisting of a laminated drawing paper on board, doesn't buckle when wet. If large areas are covered by a wash, however, some illustration boards will warp during the process of drying.

The surface can take a substantial amount of abuse, and corrections are easier to accomplish on illustration boards than on most watercolor papers. One particular technique, used to lighten values, is sanding the surface. Both watercolor paints and ink can be removed by sanding the hard surface with fine sandpaper. The sanded area will, like watercolor paper, be more absorbent to subsequent watercolor washes.

Some of the most successful watercolor paintings have been painted on Bristol Board. Although these hard, smooth surfaces may be difficult to control for the novice painter, many experienced painters will use Bristol Boards. Paints tend to sit high on the surface, producing vivid colors.

Bristol Board tends to buckle, at times severely, but if paintings are kept small in size the buckling is also kept to a minimum. If large areas are saturated with paint or water on Bristol Board, it becomes necessary to either tape or tack the board to a solid surface. If the Bristol Board isn't secured, it may curl into a roll in the process of drying.

If an absorbent paper is desired, the watercolor painter may want to turn to print papers used for intaglio or lithography. Most of these papers have little or no sizing, rendering the paper quite absorbent.

The selection of print papers is far greater than that of watercolor paper, and, in addition to a large variety of textures and weights, some are also offered in various colors.

Experimenting with other supports can be rewarding as these supports can produce results quite different from those obtained on traditional watercolor paper. If your watercolor paintings seem to get stale, or if you are tired of your paintings having the same appearance, try switching to papers made for techniques other than watercolor, such as Canson Mi Teintes.

Canson Mi Teintes

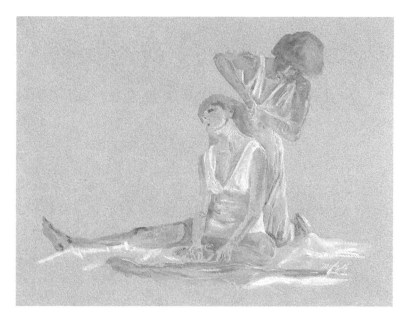

Fiber Content: 66% rag
Surface Texture: Fine tooth
Weight: Not applicable
Color: 35 colors from ivy
 through dark blue
Size: 19½" × 25½" (48 ×
 64 cm)
Price Range: $0.85 to $1.10
Absorbency: Poor
Reworkability: Poor
Watermark: None
Sizing: Weak

Models 19" × 25" (48 × 64 cm)
Canson Mi Teintes

Canson Mi Teintes is without a doubt one of the most alluring papers available. The color selection is extensive, and it is very appealing to even the most critical eye. Unfortunately, it is not made for watercolor painting, nor is it advertised as such. The primary use is for pastel and drawing, but being a paper that is in itself very attractive, many watercolor painters cannot resist trying water-based paints on Canson Mi Teintes.

Canson paper does not behave well with water. As it begins to dry, it also begins to buckle. This buckling is quite offensive in a finished product, and flattening the paper once dry is practically impossible. The only solution to painting on Canson is to stretch the paper.

Stretching Canson is a little more difficult than stretching traditional watercolor paper. It is not a very absorbent paper, and it must be soaked a little longer to assure that the paper is completely saturated. If the soaking is cut short, Canson has a tendency to shrink unevenly, leaving random buckles on the surface. If the paper is to be stretched on canvas, it is necessary to use a fairly heavy canvas for the paper to stretch flat. Material such as muslin may render the paper surface suitably level.

Once Canson has been stretched, the surface feels smoother and painting with watercolor is fairly easy. One slight drawback comes from the lack of luster that is so prevalent with papers designed especially for watercolor. The lost luster can be brought back by adding a little gum arabic to the paint. If large amounts of gum are added, the painting may look as if it has been varnished (an effect some find objectionable).

On the papers where the color is dark, it becomes necessary to use opaque paint or a dry-brush technique in order for the painting to be successful.

Canson paper will take an extraordinary amount of abuse. The surface is difficult to dissolve even after long periods of scrubbing.

RECYCLING YOUR WATERCOLOR PAPERS

For more years than I care to remember my supply of used watercolor paper was always on the rise. After having exhausted both sides and certain that it no longer had any use whatsoever, the paper would be set aside to be recycled at a later date. Recycling paper is time consuming and requires space; consequently, my used supply kept increasing. In the last few years, however, this used paper supply is decreasing, as I use it for silverpoint, pastel, watercolor, and oil painting. Using what I consider universal ground to cover existing watercolor paints gives my paper another chance to be useful.

The ground I use is a mixture of acrylic gesso and plaster of Paris. This combination is simply a modification of pure gesso made from a combination of glue (usually rabbit-skin glue) and whiting or plaster of Paris. The drawback with true gesso is that it is quite brittle, and any heavy application paper or canvas tends to crack easily. Gesso made with acrylic binder is relatively new and has one outstanding feature: flexibility. In addition to acrylics, modern chemistry has also introduced new pigments to the paint industry. The most common white pigment in acrylic gesso, which not only isn't toxic but also has great covering ability, is titanium dioxide. When acrylic gesso is combined with plaster of Paris, the resulting surface is slightly absorbent, abrasive, and can be sanded. The texture of the support can be kept intact by applying the gesso and plaster mixture diluted with water, or, if a completely smooth surface is desired, the mixture can be applied with a mason's trowel, then sanded to the desired smoothness.

To prepare the paper, I begin by soaking the used watercolor paper in a bathtub to remove as much of the paints as possible, then transfer the paper to a flat surface. Using a mixture of two parts acrylic gesso to one part plaster of Paris, the paper is coated with either a brush or trowel; when dry to the touch, the other side is coated.

Once totally dry, the surface can be sanded. If the initial coat is fairly thin and sanded, a second or third coat may be necessary to protect the paper fibers from being exposed. Exposed paper fibers are not a real problem unless oil paints are used on the paper. Cellulose fibers and oil are not compatible, as the linseed oil will deteriorate the cellulose in time. The texture of the support, whether canvas, paper, or board, can be controlled by methods of application and by sanding.

From a historical viewpoint, the most popular method of drawing and writing prior to the introduction of graphite was silverpoint. Although ink faded with time, silverpoint did not fade, and, like the modern pencil, it could easily be carried at all times. The only drawback was that each sheet of paper had to be prepared with an abrasive surface to accept the silver.

The surface of acrylic gesso and plaster of Paris provide an excellent abrasive surface that easily accepts silverpoint. The silver, however, will not tarnish to that absolutely beautiful sepia that is so apparent in old silverpoint drawings. Contrary to popular belief, the tarnishing process does not come from the atmosphere. The ground on which the silver is drawn provides the patina of the silverpoint's final appearance. Gesso made with glue and plaster of Paris will tarnish the silverpoint drawing in a fairly short time; after a year or so the drawing will appear a bit darker and have a distinct sepia appearance.

The surface of my preference is a smooth one, as texture seems to interfere with the delicate lines in a silverpoint drawing. There is one paper, however, made for silverpoint called clay-coated paper, which is very smooth; in fact, it is so smooth and even that I find it a little too perfect. Like the surface made with acrylic gesso, clay-coated paper does not tarnish the silver either. One drawing I did in 1976 is as gray today as the day it was drawn.

Prelude 20″ × 15″ (51 × 38 cm)
Silverpoint on Prepared Paper

Watercolor paper can be prepared with acrylic gesso and plaster of Paris, making it ideal for silverpoint drawings.

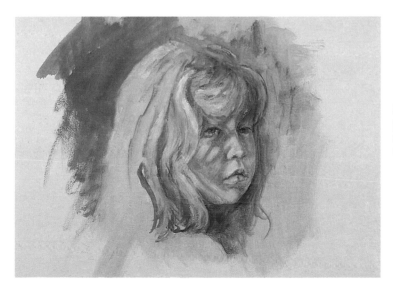

Recycling your used watercolor paper can open the door to new media. This is an example of watercolor paper treated to take oil paint.

Rachel 16″ × 22″ (41 × 56 cm)
Oil on Prepared Paper

GLOSSARY

Bast fiber The inner bark of plants, such as flax, hemp, gampi, used in the production of textiles and paper.

Blocks Sheets of paper held together on all four edges by glue and light fiber. They usually contain 15 to 25 sheets ranging in size from 9″ × 12″ to 18″ × 24″. Even though glued on four sides, such papers will buckle during the painting process but will usually dry flat.

Buffer A chemical that resists the change of the hydrogen-ion concentration in a solution.

Capillary action The ability of a porous substance to attract a liquid.

Capillary ridge A ridge of watercolor pigments formed by paper drying unevenly.

Cellulose The chemical substance that forms the walls in plants occurring mainly as hollow tubes called fibers. Cellulose is the chief component of paper made from vegetable matter.

Colloidal suspension A state of suspended particles in a liquid. The state between a liquid and a true solution.

Deckle A wooden frame sitting on top of the mold preventing the paper pulp from running off during dipping.

Deckle edge A feathered edge created by the deckle frame in the production of handmade paper.

Filler Materials added to paper pulp prior to the formation of the sheets. The material fills the pores in the paper fibers, resulting in a harder, more opaque, and often whiter paper. Most fillers are clay or calcium carbonate or a combination.

Flax fiber The bast fiber of the flax plant used in the production of linen and paper.

Gelatin A protein made from animal tissue used as sizing to control the absorbency of watercolor paints or inks on paper.

Glazing A transparent film of paint laid on top of another color. Almost all colors can be used as a glaze providing the color is thinned enough to become translucent or transparent.

Grain The predominant direction of paper fibers in machine-made paper.

Laid The impression in paper formed by thin wires on the mold supporting the paper pulp in the papermaking process.

Mould or Mold The basic tool for papermaking. A wire screen stretched on a wooden frame that when dipped into paper pulp forms a fibrous mat allowing the water to drain from the pulp forming a sheet of paper.

Paper A fibrous mat produced by suspending fibers in water and made to flow across a screen, allowing the water to drain.

Rag A term used to describe the amount of natural fibers relative to the total amount of material in a given paper. It is expressed in percentage, such as 100% rag content or 50% rag content.

Sizing A glue-like substance incorporated in papermaking. It can be added to, or after, sheet formation. Sizing controls absorbency of the paper and the ability of the sheet to accept inks without feathering.

Sulfate process The process of converting wood chips into pulp by cooking under pressure in a solution of sodium sulfide, sodium hydroxide, and water.

Sulfate paper Paper made from pulp produced by the sulfate process.

Sulfite process The process of producing wood pulp by cooking wood chips in a solution of sulfuric acid and bisulfite of calcium, sodium, or ammonium.

Waterleaf Paper without any sizing.

Watermark A translucent area in a sheet of paper, often in the form of a design identifying the manufacturer.

Wet on wet The watercolor technique of painting on a wet surface, utilizing capillary action to distribute the pigments. The entire sheet or part can be utilized when painting wet on wet.

Wove The term used for classifying paper without lines produced by a mold.

INDEX